D1357734

501 201 744

watercolour simplified

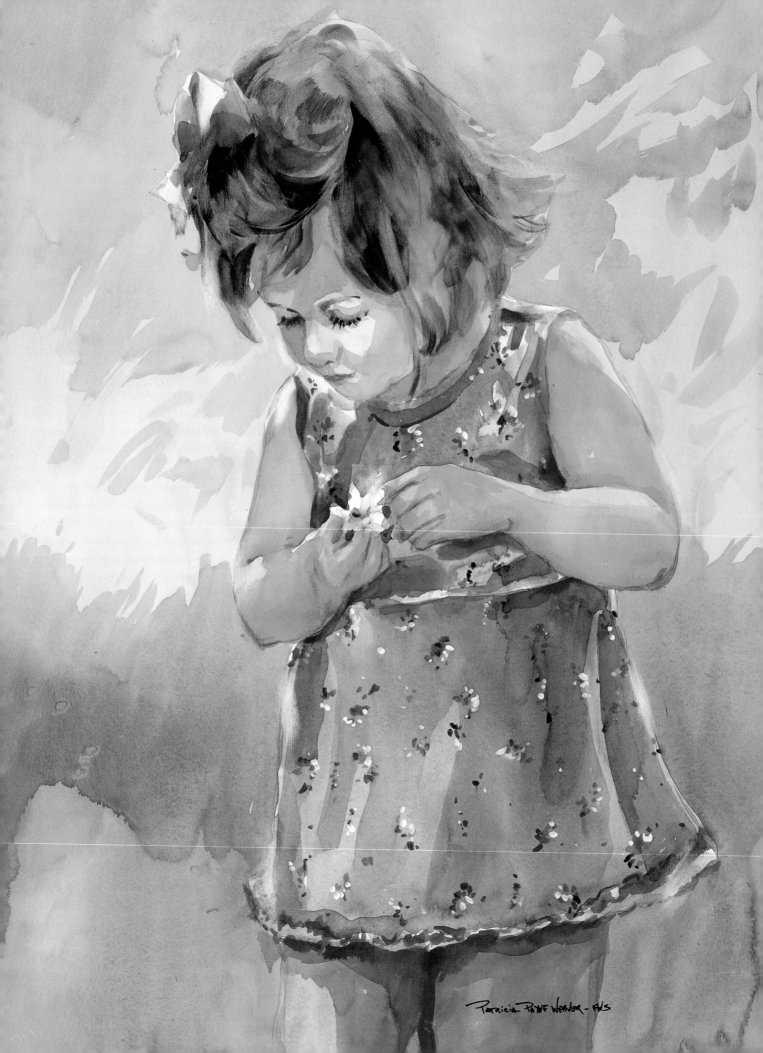

Patricia Payne Weaver - FWS

watercolour simplified

pat weaver

David & Charles

Art on page 2: **Picking Posies** • *30" x 22" (76cm x 56cm)* • *Collection of the artist*

about the author

Pat Weaver is a national watercolor teacher with over thirty years of teaching experience. Her own education in art has been through workshops and disciplined practice. She is past president and signature life member of the Florida Watercolor Society; a signature member of the Georgia Watercolor Society, and a member of the Miniature Society of Florida.

Pat has been featured in *The Artist's Magazine*, *Watercolor 96*, *Splash 7* and *Watercolor Magic*. Pat has served in many local offices. She was mayor and city commissioner of Dade City, Florida, president of the chamber of commerce, president and founder of redevelopment, Downtown Dade City Main Street.

Pat teaches watercolor workshops nationally and travels overseas teaching in France, Italy and Great Britain. Her workshops are so popular and well received that many students sign up for multiple workshops. She offers classes in many subjects including Portrait and Figure, Landscapes, Floral and Still Life, Animals, Drawing, and Color Theory.

She conducts a number of workshops in her studio in Dade City and maintains a vigorous teaching schedule at various other venues. Pat's watercolors and teaching schedule can be viewed from the website: www.watercolorplace.com. She is available to teach a workshop at your location.

A DAVID & CHARLES BOOK

First published in the UK in 2003
First published in the USA in 2003 by North Light Books, Cincinnati, Ohio

Copyright © Pat Weaver 2003

Pat Weaver has asserted her right to be identified as author of this work in accordance with the Copyright, Designs and Patents Act, 1988.

A catalogue record for this book is available from the British Library.

ISBN 0 7153 1734 2

Printed in China by Leefung-Asco
for David & Charles
Brunel House Newton Abbot Devon

Visit our website at www.davidandcharles.co.uk

David & Charles books are available from all good bookshops; alternatively you can contact our Orderline on (0)1626 334555 or write to us at FREEPOST EX2 110, David & Charles Direct, Newton Abbot, TQ12 4ZZ (no stamp required UK mainland).

Edited by James A. Markle
Designed by Wendy Dunning
Production art by John Langen
Production coordinated by Mark Griffin

Metric Conversion Chart

To convert	to	multiply by
Inches	Centimeters	2.54
Centimeters	Inches	0.4
Feet	Centimeters	30.5
Centimeters	Feet	0.03
Yards	Meters	0.9
Meters	Yards	1.1
Sq. Inches	Sq. Centimeters	6.45
Sq. Centimeters	Sq. Inches	0.16
Sq. Feet	Sq. Meters	0.09
Sq. Meters	Sq. Feet	10.8
Sq. Yards	Sq. Meters	0.8
Sq. Meters	Sq. Yards	1.2
Pounds	Kilograms	0.45
Kilograms	Pounds	2.2
Ounces	Grams	28.4
Grams	Ounces	0.04

dedication

This book is dedicated to Glenn, my very special husband, best friend, art critic and steadfast encourager. Thank you for your love, wise counsel, patience, support and for believing in me.

acknowledgments

This is without a doubt the most important and challenging project that I have ever undertaken. Much thanks to my editor, Jamie Markle, for his guidance and for keeping me on track. Without a great editor, this job would be truly overwhelming. Thank you to everyone at North Light that had a part in the designing of this book.

A special thank you to Sandra Carpenter and Rachel Wolf for giving me the opportunity to write *Watercolor Simplified*.

And to all the many students who have been supporting me throughout the years; I've learned so much from each of you, and without you this book would not be possible. Sharing what I know about painting is one of the greatest joys in my life.

Little Green Pitcher • *11" x 15" (28cm x 38cm)* • *Collection of Margaret Roberts*

foreward

The watercolor medium is much more versatile than a lot of people realize. There are many ways to approach it, but without a doubt the best way to begin a painting is with a sense of adventure. Watercolor is a very spontaneous and active medium, and this is particularly true at the hand of Pat Weaver.

I am fortunate to count Pat as one of my very good friends and I am forever amazed at her ability to get things accomplished. She is an exceptional artist, and has a tremendous talent and dedication for teaching as well. Pat brings an understanding to the fluid and exciting aspects of painting in watermedia—she is fearless in her application, and the resulting art is enchanting in its freshness.

Heide E. Presse, NWS

table of contents

chapter one
welcome to my studio 11

Join Pat on a tour of her studio, where you will see the basic materials and tools you need to get started on your own watercolor paintings.

chapter two
basic fundamentals 19

Explore the five elements needed to create simplified watercolor paintings: the camera and photography, the template, the golden mean, color palette and thumbnail sketches.

chapter three
drawing simplified 35

Strong drawing skills are essential to good paintings. Pat will show you several quick methods for capturing your subject in a variety of mediums.

chapter four
value simplified 55

Changes in value create interest; without interest you have boring paintings. Pat makes this key concept to creating great paintings as easy as seeing black and white.

chapter five
color simplified 69

Color can be very simple or it can be quite complex. Pat will show you how to conquer color using triads and limited palettes that make using color enjoyable.

chapter six
demonstrations 89

Nine direct painting demonstrations show you how to tie all the concepts in this book together. Subjects include flowers, buildings, cats, dogs, rabbits and roosters.

conclusion and gallery of work 118

Take a brief walk through Pat's gallery to view a selection from her wide range of work.

Introduction

Through many years of teaching, I have developed a way of presenting material to students that is uncomplicated and introduces them to sound principles that are easily understood. A beginning student, virtually clueless about what to do in a workshop on Monday, is painting with a certain degree of confidence by Friday. Why? Because they learn the sound principles on which to build a painting.

Claude Croney said, "There are five basic building blocks in art: drawing, composition, value, color and technique. If you could dispense with any one of these, it would be technique." Technique is something that should come after you fully understand the basic principles and are able to apply them. Sadly, today many students just want to paint pictures. They choose to skip over the fundamental building blocks of art. They don't realize that they are bypassing the principles that will serve them throughout their painting life and help them produce good works of art.

I've discovered that as soon as a student has a clear understanding of how to put a painting together, the intrigue and excitement set in. Stimulated by their newfound knowledge, they soon learn that without order and discipline there is chaos. So, there it is in a nutshell—you can't skip over the basics.

This is a no-frills book. I've tried to write it in a way that simplifies painting. You won't have to deal with stretching or stapling the paper. No masking with frisket. Tricks like salt and plastic wrap aren't used. There's no pouring of paint and definitely no projecting an image onto the paper—learning to draw is a must! There's just painting directly on the paper without wetting the paper first. This book is pure, unadulterated painting in transparent color using your brain and your brush. This book presents a simplified approach to drawing, design and composition, cropping, value painting, color mixing and oh yes, we learn about those all important edges. Remember, less *can* be more.

It is my hope that you will be inspired by my paintings and demonstrations. I want to challenge you to give up a few things in order to achieve your dream of becoming an accomplished painter in watercolor. I was once asked a mind-boggling question by a fascinating Canadian artist, A. D. Greer. I expressed to him my burning desire to paint and to be very good at it. In the middle of my exuberance, he placed his hand on mine and said, "What are you willing to give up for your art?" I pondered this question many times over the next thirteen years, knowing full well that there really wasn't very much that I could give up for my art as I was raising my two children, heavily involved in my community, serving as a city commissioner and then mayor. But, I have to tell you, I still found the time to paint and teach, because I wanted it badly enough. If that fire is in your belly, you'll do it too. A. D. Greer's profound words are still with me today and the understanding of his question is becoming clearer year by year. One cannot be all things to all people all of the time. If you really want to excel, no matter what you are trying to do or become, you must stay focused.

You may only want to paint for your own enjoyment or you may be seriously considering a career in art. The one thing we have in common is the drive within us that says, "I have to create art." It is the passion in my life. I'm happiest when I have a brush in my hand and can see and feel the paint dancing on the paper. I just cannot imagine living my life without the joy of painting.

Finally, always keep the following in mind: There are no shortcuts to anything worth having. It takes self-discipline, which leads to motivation, which leads us all to good study and the desire for excellence. Enjoy!

Sunflowers of Sienna • 30" x 22" (76cm x 56cm) • *Collection of the artist*

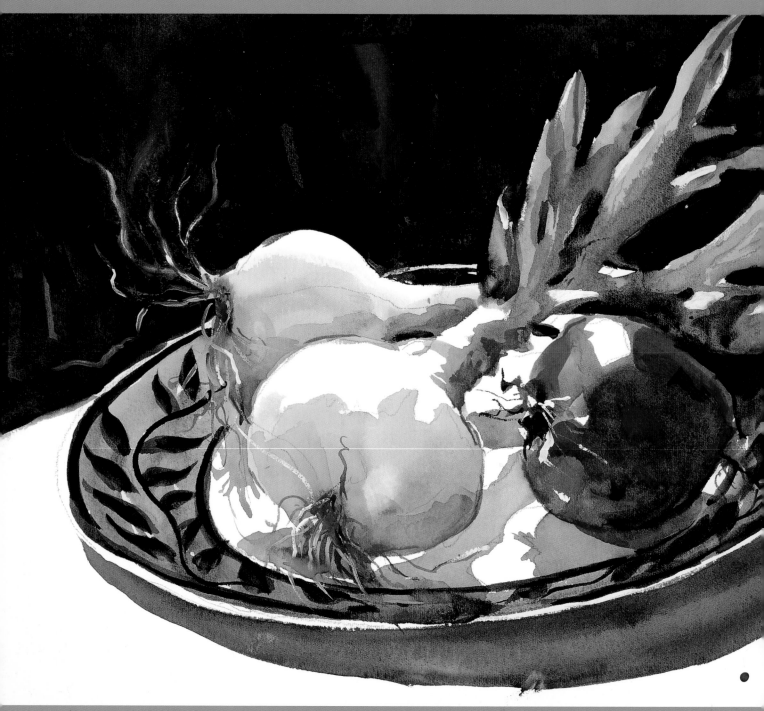

Still Life With Onions • *15" x 22" (38cm x 56cm)* • *Collection of the Jane Feiten*

welcome to
my studio

Everyone needs a space and the right tools to create their art. Good quality paper, paint and brushes are an important and necessary component in painting. We will look at painting on different paper surfaces as well as review a suggested range of color choices and a selection of the brushes that I use most often. Each artist eventually settles down with their own favorites. The extra items I use are essential to my painting process. I must have soft absorbent paper towels, not that stiff, nonabsorbent stuff, and an old piece of terry cloth, then I'm happy. This chapter will also provide an overview of the layout of my workspace and some fun pieces of arty furniture that enhance my studio.

The studio

The dictionary defines a studio as the workplace of a painter or sculptor. I can take that further by saying that it is much more than just a workplace. It's a personal space, a crucial and important element to creative ideas where you can get lost in your thoughts. The studio is a place to move away from the everyday things that have a way of interfering with serious painting time. You can walk out, shut the door and leave everything just as it is, until you walk back in to reenter the painting process.

When I'm not on the road teaching, this is where I spend most of my waking hours. This studio is my refuge; a comfortable, happy place where I'm surrounded by my books, classical music, paintings and photos of my family.

It has north light windows and at the south end large windows that look into the woods. It was designed also for teaching and is spacious enough to accommodate up to twenty-three students for workshop classes. The studio has a full bathroom, a large cast-iron sink I found in a consignment shop, a refrigerator, a storage room and an office area, which houses my computer, printers, flat files and other office necessities.

Welcome Students

Students that pass through these doors have their lives changed for the better through a joyous learning experience.

Dream Studio

For twenty-five years, I dreamed of having the perfect place to paint. That dream came true three years ago when my husband built a spacious 1500-square-foot studio for me. It's on thirty-five acres of high rolling hills and provides me not only an outstanding location for teaching watercolor workshops, but affords me the opportunity to share with my students where I live and work.

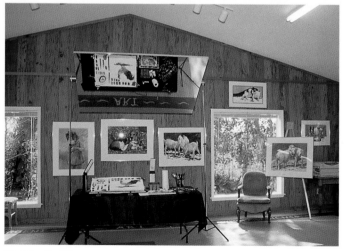

My Studio Mirror

The south end of the studio shows the six-foot overhead mirror used for painting and teaching; the large windows overlook the woods.

Setting Up Your Studio

The place you choose for a studio or workspace might be your kitchen table, extra bedroom or a well-lit large space such as mine. However large or small, plain or fancy, make the best of the space you have. I painted for many years on a back porch and then in a very small bedroom. Having a well-organized work area that is free of clutter really helps. Everything that you need for painting should be within easy reach. I am right-handed, so my palette, water container, brushes, tubes of paint, paper towel, terry cloth rag and pencil are on my right. Generally, reference material such as a photo or value sketch is in my left hand while painting. Other essentials are to the left of the support board.

Find a subject that is compelling, put on some classical music, shut the door to outside disruptions and wonderful things can begin to happen in the studio. The best of everything happens in painting when you move into the zone. This is not an everyday occurrence, rare in fact. It only happens when you become so immersed in painting, that you become totally oblivious to everything. It's as if someone else was holding the brush and you are the observer. This experience is hard to explain unless you've had it—and hopefully you will.

Studio Setup
The north end of the studio houses my sink, refrigerator, closet, office space and, of course, those all important windows letting in light from the north.

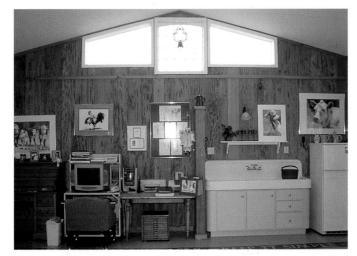

Convenience Is Key to My Setup
The painting board is slightly elevated on support boards. The brushes, paint, water, paper towels, etc., are placed to the right for easier access when I am painting.

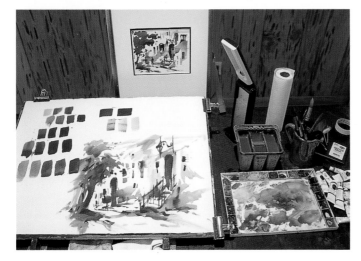

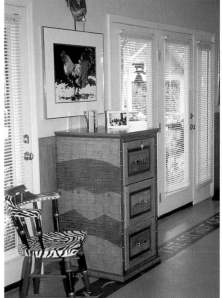

Add Personal Touches to Your Studio
This file cabinet came from Santa Fe; it just begged to come home with me, so it has a special place in my studio. The hand-painted chair is a favorite of mine.

Color

I use transparent watercolor from tubes as I require a juicy consistency to create fresh, direct and spontaneous paintings. I use several brands of paints in my paint box that have become staples over my many years of painting. It is very important to invest in high quality, professional grade paint because student grade paint does not have the brilliant color or strength of the more expensive pigments.

Beginning students tend to be conservative when it comes to spending money on supplies. I suggest that you invest in the larger tubes of transparent watercolors as they last longer and you'll feel at ease squeezing ample amounts of paint onto the palette. Paint like you're wealthy; you'll be better for it.

Transparent watercolor is my primary medium, although I use gouache or casein from time to time. It's always fun to try new approaches and mediums. Sargent used white pigment all the time in his watercolors, but I prefer to capture the white of the paper instead. The demonstrations throughout this book require only transparent watercolors. My choice of colors has changed over the years and I rarely use more than five different tubes of color in any painting. It's fascinating to see how a limited palette can simplify and unify a painting, making it more pleasing to the eye.

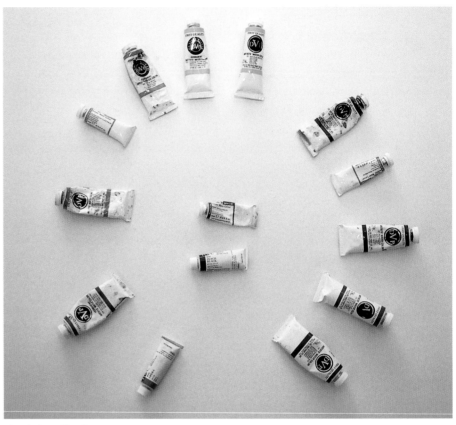

The Color Wheel
These paint tubes are laid out like a color wheel, starting with Aureolin at the top, going clockwise to Phthalo Green, Cerulean Blue, Phthalo Blue, Cobalt Blue, Ultramarine Blue, Opera, Red Rose Deep, Cadmium Red Light, Quinacridone Gold, Yellow Ochre, Cadmium Yellow Light. Burnt Sienna and Peach Black are in the center of the wheel.

My palette

The colors and brands I use most often are
• Aureolin Yellow, Da Vinci • Burnt Sienna, Winsor & Newton • Cadmium Red Light, Da Vinci • Cadmium Yellow Light, Da Vinci • Cerulean Blue, Winsor & Newton • Cobalt Blue, Da Vinci • Opera, Holbein • Peach Black, Holbein • Phthalo Blue, Da Vinci • Phthalo Green, Da Vinci • Quinacridone Gold, Winsor & Newton or Daniel Smith • Red Rose Deep, Da Vinci • Ultramarine Blue, Da Vinci • Yellow Ochre, Da Vinci

Colors I occasionally use are • Alizarin Crimson, Winsor & Newton • Brilliant Orange, Holbein • Burnt Umber, Holbein • Cadmium Orange, Holbein • Lemon Yellow, Holbein • Manganese Blue, Holbein • Quinacridone Rose, Daniel Smith • Quinacridone Sienna, Daniel Smith • Permanent Rose, Daniel Smith • Raw Sienna, Daniel Smith • Sap Green, Daniel Smith • Viridian, Daniel Smith • Winsor Red, Winsor & Newton

Paper

Having tried various brands and weights of watercolor paper, I always seem to return to my old standby, Arches. It is very forgiving and allows for scrubbing and lifting without damaging the surface of the paper. Most of my watercolors are painted on 140-lb. (300gsm) cold-pressed or 140-lb. (300gsm) rough. I also enjoy the slick surface of 140- lb. (300gsm) hot-pressed. Most commissioned works are painted on 300-lb. (640gsm) paper. I generally recommend that new students purchase 140-lb. (300gsm) cold-pressed as it is the easiest of the three surfaces to paint on. The most economical way to try different paper is to purchase a mixed packet of watercolor paper, which will contain several different brands, sizes, surfaces and weights.

Be sure to have clean hands when handling watercolor paper as the oil from your fingers may cause blotches when the watercolor is applied.

Watercolor paper comes in a variety of forms and sizes. I prefer to purchase mine as full sheets of paper instead of pads. A full sheet of watercolor paper measures 22" x 30" (56cm x 76cm). I often divide my paper into half sheets measuring 15" x 22" (38cm x 56cm), or quarter sheets measuring 11" x 15" (28cm x 38cm). You can tear or tape off the full 22" x 30" (56cm x 76cm) sheet of paper into any shape you want.

I don't concern myself with which side of the paper I paint on. If you use Arches, either side is fine. You can tell if your paper is dry by placing the back of your hand to the paper. If the paper feels cool to the touch, then the paper is not dry. Another way to test dryness is to wave the paper back and forth. If the paper makes a whoop-whoop sound, it's still wet. If it makes a pop-pop sound, it is thoroughly dry.

The water test

Here's a little experiment for you to try. Select a painting on Arches paper that has been allowed to dry for several days. Turn on your water faucet, place the painting directly under the running water and move it back and forth. The paint should not bleed from the force of the water hitting the paper. Or run water in the bathtub, place the painting in the tub and allow it to sink to the bottom. Let the painting stay there for as long as you want. When it is removed, it will look the same, probably brighter but with no bleeding of color. This works with most quality paper and paint. The paint only moves if it is disturbed by your hand, a sponge or by a brush in an abrasive manner. There are many excellent papers on the market today and this experiment should work with most of them. Just to be on the safe side, try this on a painting that you aren't particularly fond of.

Rough Paper
Study of Babe was painted on 140-lb. (300gsm) rough Arches using the same palette as *Violet Study* and *Villa Study* (right). This was painted very quickly, trying to capture the personality of the dog without detail. There is no pencil used. The same painting approach was used in all three studies. The paper finish makes very little difference in the way the paintings look, but the paper surface reacts somewhat differently when the paint is applied.

> *Study of Babe* • *140-lb. (300gsm) rough Arches* • *11" x 15" (28cm x 38cm)* • *Collection of Jane Frist*

Cold-Pressed Paper
Villa Study was painted directly on cold-pressed paper with no pencil using the red, yellow and blue triad.

> *Villa Study* • *140-lb. (300gsm) cold-pressed Arches* • *11" x 15" (28cm x 38cm)* • *Collection of Thom Graves*

Hot-Pressed Paper
Violet Study was painted directly on 140-lb. (300gsm) hot-pressed Arches with no pencil using the red, yellow and blue triad.

> *Violet Study* • *140-lb. (300gsm) hot-pressed Arches* • *11" x 15" (28cm x 38cm)* • *Collection of Mrs. Dian Felder*

Brushes

Brushes vary from manufacturer to manufacturer. For example, a no. 24 round synthetic sable from Loew-Cornell will not be the same as a no. 24 round synthetic sable from Prolene by Pro Arte. If a certain brush is required by an instructor for your art class, it helps to know the manufacturer, size, shape and stock number. All this is listed on the handle.

Buy the best brushes you can afford. Brushes that flop over when you paint are not recommended. A good quality brush will hold its shape when painting. A good test is to wet the brush thoroughly in water and give it a good shake. If it snaps back to its original shape, it's a good brush.

Don't leave your brushes standing in water. This is the kiss of death for a brush, even the best ones. The hairs will lose their shape and the prolonged standing in water will ruin the metal ferrule and rot the wooden handle. When caring for brushes, rinse them in clean water, store them either in a brush holder or other upright container that is weighty enough not to topple over.

Remember, there is no *magic* brush. Quality brushes are a must, but brushmanship only comes through knowledge gained by paying your dues with many hours of practice. Proficiency comes with painting three-hundred to five-hundred watercolors per year. Now before you feel totally overwhelmed by that statement, these paintings can be quarter sheets, not necessarily half or full sheets. As you gain experience and confidence your speed will increase making it possible to paint several small watercolors in a couple of hours. I affectionately call these warm-ups. Once you are warmed up, you're ready to paint the half and full sheets. Warming up is a good habit, which is no different than a pianist that practices scales and chords before attacking Rachmaninoff's Prelude in C-sharp Minor or Pavarotti warming up his vocal chords backstage before performing in the opera, *La Boheme*.

My brushes

I work with synthetic sable flats, angular flats, rounds and riggers.

My flats are:
* ½-inch (12mm) flat no. 7010 from Richeson
* 1-inch (25mm) Silver Ruby Satin 2514S wash
* 1-inch (25mm) no. 7400 angular flat by Loew-Cornell
* 1½-inch (38mm) Silver Black Velvet no. 3014S wash
* 2-inch (51mm) Loew-Cornell no. 7750

My rounds are:
* No. 8 Richeson 7000 Series
* Nos. 20 and 24 Prolene by Pro Arte 101 series

My script liner is:
* No. 2 Loew-Cornell 8050 Series Mixtique

Brushwork tips

* Begin the painting with bigger brushes, finish with smaller ones.
* Painting with very small brushes from beginning to end usually creates a very tight painting.
* Paint the big simple shapes first, keeping the painting loose for as long as you can, then graduate down to the smaller brushes for any detail, calligraphy or signature.

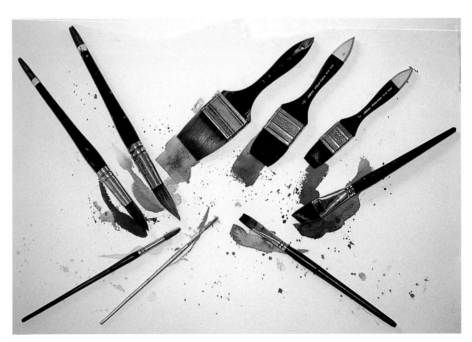

My Brushes
Here are just some of the brushes I use when painting. Starting in the lower left is the no. 2 rigger, no. 8 round, no. 20 round, no. 24 round, 2-inch (51mm) flat, 1½-inch (38mm) flat, 1-inch (25mm) flat, 1-inch (25mm) angular flat and ½-inch (12mm) flat.

Other essentials

Since my approach to painting is very direct and simple, the other essentials are kept to a minimum. You may find that you require more extras to help you in your own endeavors, but I prefer as little as possible to keep up with, eliminating any unnecessary clutter.

The additional supplies I use are:

✷ Board supports

✷ Bulldog clamps

✷ Gator board 23" x 31" (58cm x 79cm)

✷ Kneaded erasers

✷ Koh-I-Noor Hardtmuth Progresso 8911 in 2B, 4B and 6B drawing pencils

✷ Masking tape

✷ Mat with 4" x 6" (10cm x 15cm) opening

✷ Mat with 8" x 10" (20cm x 25cm) opening

✷ No. 2 pencils

✷ Sharpie Twin Tip double-ended marker

✷ Single-edge razor blades

✷ Sketchbook 8½" x 11" (22cm x 28cm)

✷ Soft paper towels

✷ Template

✷ Terry cloth rag

✷ Toothbrush

✷ Water bucket

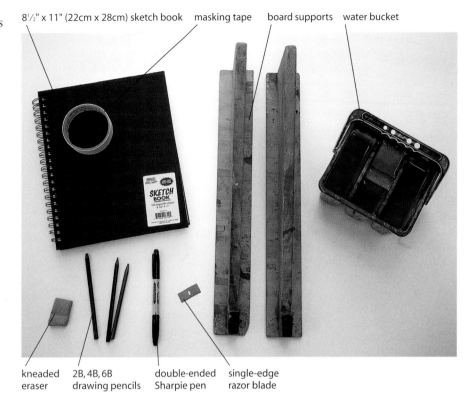

8½" x 11" (22cm x 28cm) sketch book · masking tape · board supports · water bucket

kneaded eraser · 2B, 4B, 6B drawing pencils · double-ended Sharpie pen · single-edge razor blade

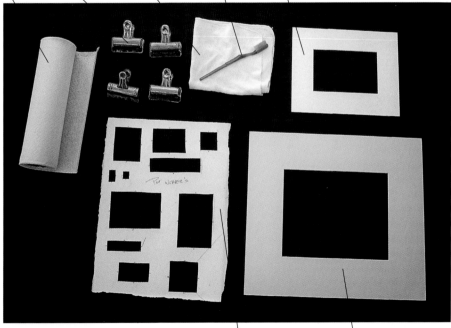

paper towel · Bulldog clamps · terry cloth rag · toothbrush · 4" x 6" (10cm x 15cm) mat opening

template with multiple-sized openings · 8" x 10" (20cm x 25cm) mat opening

Studio Essentials
Here are just some of the tools I use when painting. Most of the items you can find around your home or at your local art supply store.

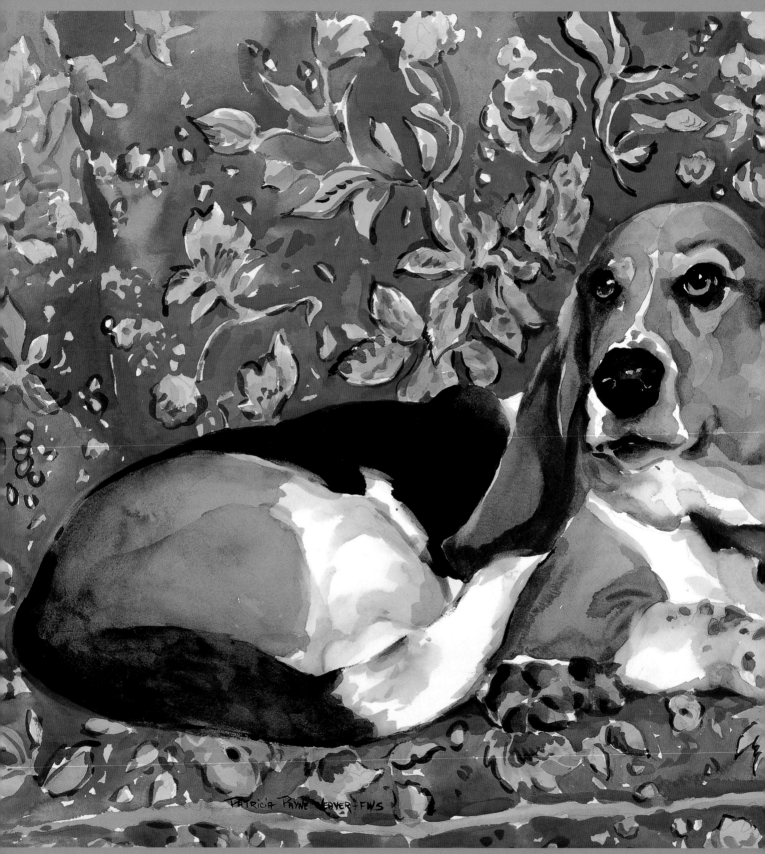

Beau on Red • 22" x 30" (56cm x 76cm) • *Collection of the artist*

basic
fundamentals

Explore five elements: the camera and photography, the template, the golden mean, dominant temperature of color, and thumbnail sketches. Each element is helpful in simplifying your approach to painting in watercolor. The painting process often begins with the use of a photograph, preferably one that you have taken. You need to know how to make the best use of your camera and lighting. The template with its multiple-sized openings and shapes is a great aid in cropping and composing the subject to be painted. A formula for the golden mean, a powerful element in composition, is explained in a simple manner, as is choosing a palette, recognizing the temperature of colors and temperature dominance. Small and simple thumbnail sketches are the backbone of any successful painting, and are necessary for working out composition and design, values and linkage.

How to shoot good photographs

Taking reference photos is a great way to capture an image you want to paint. It is also a useful tool for creating good compositions. It is very important to take time to study your subject before taking the picture. Ask yourself what it is about the subject that appeals to you and why you are attracted to it. Is it the way the light strikes a building? The landscape? A person's face or clothes? Would the subject be better painted close-up or at a distance? Make sure that the focal point is not in the center of the photo, too high or too low, too close to the edge, too small or swallowed up by too much space around it.

I take my camera and plenty of film everywhere I go. You never know when that once-in-a-lifetime shot is going to present itself and you will kick yourself if you don't have a camera.

My 80-300mm zoom lens is my favorite as it allows for spontaneity. As an overall lens, it is great; it can be used for landscapes, animals, still lifes and more. I use a 28-80mm lens for shooting interiors and slides of my finished paintings. My Canon Speedlite 420EX flash attachment provides a greater amount of light than the built-in flash.

When photographing people, I enjoy the use of *candid photography* to capture them when they are unaware, fully relaxed and not distracted by the camera. For painting close-ups of people, I look for a linking shadow shape on the face, neck and shoulders. The best way to accomplish this is by shooting in direct sunlight. Make sure the model is not looking directly into the sun. The light should strike the face from either the left or right, creating a strong shadow on the opposite side.

Bright light creates contrast between shadow and light. The most exciting time to take photographs is in the morning before 11 A.M. and after 3 P.M. in the afternoon. Photos taken in the middle of the day are flat and less interesting. Overcast days are interesting to paint when working on location, but photos taken on cloudy days are not very inspirational when using them in the studio. Never shoot into the sun, this causes flares in your photographs.

Photo checklist

I use the following supplies when taking photographs:

Camera
Canon Elan 7 35mm

Film
Fuji 200 35mm for indoor and outdoor photos

Kodak Professional E200 Ektachrome for indoor slides

Fuji Velvia Daylight for outdoor slides

Flash Attachment
Canon Speedlite 420EX

Lens
Canon EF 80-300mm zoom lens with image stabilizer

Canon EF 28-80mm zoom lens

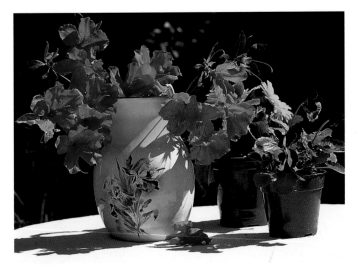

A Quality Photograph
The quality of this photograph is good but the composition could be better. It was shot at eye level. The azaleas are too equal on each side of the pitcher and the shadows are boring.

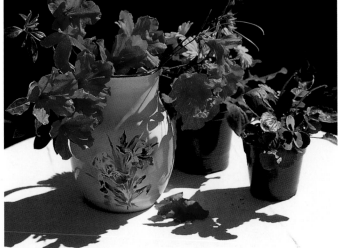

A Better-Composed Photograph
When the subject is shot from above, the shadows become much more interesting. The flowers are in the same position but will be altered in the painting.

Creating paintings from photographs

Photography is a terrific asset in painting as long as you don't fall into the trap of painting an exact copy of your photograph. The photograph is for inspiration and reference, and a tool for ideas, composition and design. The camera does not always tell the truth about a subject especially when it comes to shadows. The human eye sees into low-light areas, but the camera records it as dark or black in the photograph.

Only work from photographs that you take yourself. Determine the composition of the subject in the lens of the camera, making it uniquely yours.

Often, I make black and white copies of my color photographs to simplify the values. It makes it easier to depart from the actual colors in the photograph and allows for more creativity. It also inhibits the tendency to copy everything and

allows you to be ruthless about what to leave out.

Remember to paint on location as much as possible. This teaches you to visually organize and eliminate unnecessary elements, which helps you create good compositions. As wonderful as the camera is, it cannot substitute for your own eye, so use it wisely.

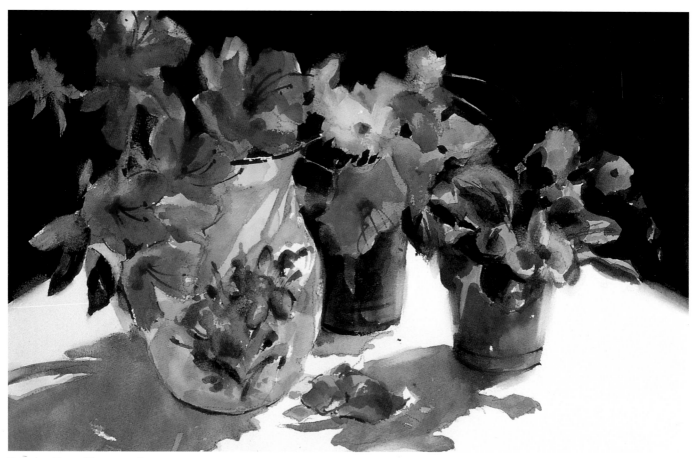

Painting From Photographs
The bright yellow light and shadow on the pitcher is the focal point of this painting. The basic composition is taken from the photograph but I used some artistic license to slightly exaggerate and rearrange the flowers.

French Enamel Pitcher • *15" x 22" (38cm x 56cm)* •
Collection of Barbara Aras

Create your own work

Do not copy other people's work for competition or for gallery sales. This includes photos out of magazines, books, master paintings, etc. It is unethical and can get you into trouble. Besides, you'll feel great when you know that everything about your painting is yours and yours alone. It's OK to copy paintings out of art

books if you're learning, but it's not OK to sell or put them on public display. For competitions, never enter a painting that you have copied, painted in a workshop environment or one that has been painted from the instructor's photos that are intended for class work only. It must be your original work of art.

Using a template for composing paintings

The template is a useful tool for cropping photographs or drawings. Each opening is similar to using a mat for cropping, but gives you many more choices because there are various-sized openings in the template. Once you choose one of these openings, you refer to it as your *compositional format*—the shape of the painting and whether it will be horizontal or vertical. This is a major decision made before beginning any painting.

The template helps you isolate areas in a photograph not easily seen when looking at the image as a whole. You can find multiple compositions in one photograph, which could become a series of paintings, by trying different openings in the template. When placed over different sections of a finished painting, you will find abstractions and locate paintings within a painting.

Here are four examples using the same photograph. Each composition is different and shows you the potential of different approaches to creating a painting. Note that in each example, the sheepherder is always placed as the focal point.

Capturing the moment

I took this photo in Provence, France, where I was teaching a workshop. Everyone was painting these buildings, when all of a sudden a sheepherder, his dogs and sheep rounded the bend in the road. Using my zoom lens, I captured this wonderful scene. In less than five minutes, the sheepherder and his sheep had moved out of view. It was a perfect moment in time, totally unexpected. It was just what I always hope for when working outdoors. You can see how a series of paintings could be made from this one great photograph. In each format, the sheepherder is the center of interest, putting to practice the theory of the golden mean.

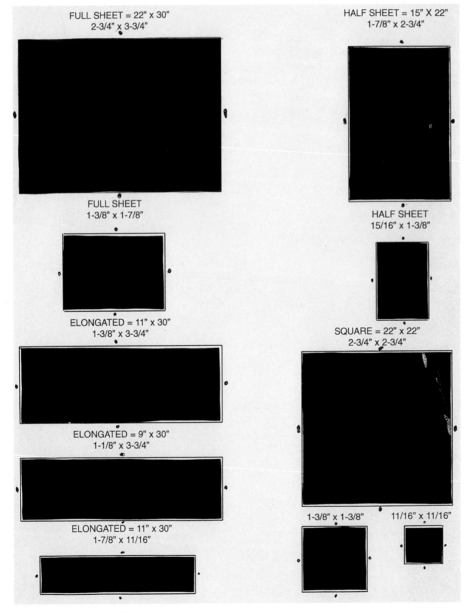

FULL SHEET = 22" x 30"
2-3/4" x 3-3/4"

HALF SHEET = 15" X 22"
1-7/8" x 2-3/4"

FULL SHEET
1-3/8" x 1-7/8"

HALF SHEET
15/16" x 1-3/8"

ELONGATED = 11" x 30"
1-3/8" x 3-3/4"

SQUARE = 22" x 22"
2-3/4" x 2-3/4"

ELONGATED = 9" x 30"
1-1/8" x 3-3/4"

ELONGATED = 11" x 30"
1-7/8" x 11/16"

1-3/8" x 1-3/8" 11/16" x 11/16"

The Template

Making a template is easy. All you will need is a quarter sheet, 11" x 15" (28cm x 38cm) piece of cold-pressed watercolor paper, a pencil, a small ruler and a single-edge razor blade or craft knife to duplicate the template. Make a photocopy of this template found on page 127, so you can use the template to compose your own paintings. Simply cut out the boxes from the photocopy and trace them onto your watercolor paper. Then cut out the shapes on your watercolor paper to create a durable template to work from.

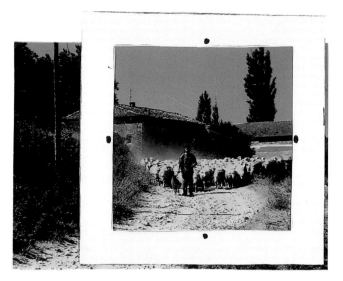

Square Format

The square format can be used in three different variations: 1) 2³⁄₄" x 2³⁄₄" (70mm x 70mm), 2) 1³⁄₈" x 1³⁄₈" (35mm x 35mm) and 3) 1¹⁄₁₆" x 1¹⁄₁₆" (27mm x 27mm). All three are the same shape as a 22" x 22" (56cm x 56cm) square piece of watercolor paper. This example uses the 2³⁄₄" x 2³⁄₄" (70mm x 70mm) template.

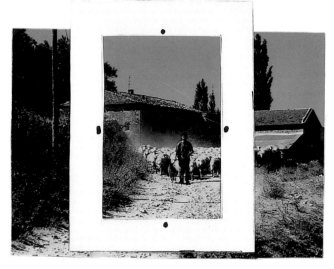

Vertical Format

This vertical rectangle measures 1⁷⁄₈" x 2³⁄₄" (48mm x 70mm). It has the same proportions as a 15" x 22" (38cm x 56cm) half sheet of paper. Another vertical rectangle measuring 1⁵⁄₁₆" x 1³⁄₈" (33mm x 35mm) would be a smaller template, but with the same proportions as the half sheet of watercolor paper. Both shapes have equal proportions, one larger, one smaller. By turning the template sideways, the vertical shapes become horizontal.

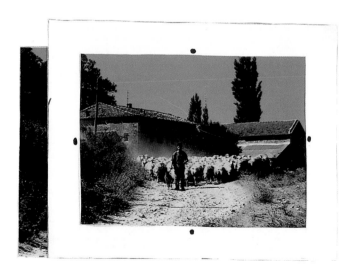

Horizontal Format

This horizontal rectangle measures 2³⁄₄" x 3³⁄₄" (70mm x 95mm). This will be exactly the same proportion as a standard 22" x 30" (56cm x 76cm) full sheet of watercolor paper. You may also use a rectangle measuring 1³⁄₈" x 1⁷⁄₈" (35mm x 48mm) for a smaller shape that still equals a 22" x 30" (56cm x 76cm) piece of paper. By turning the template sideways, the horizontal rectangle can become a vertical.

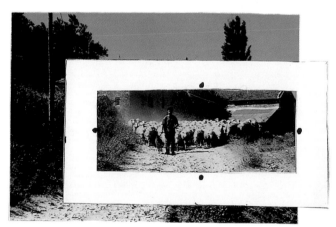

Elongated Format

Elongated formats can be very dramatic. This one measures 1¼" x 3¼" (32mm x 83mm). Other elongated shapes can measure 1³⁄₈" x 3³⁄₄" (35mm x 95mm) and 1¹⁄₁₆" x 1⁷⁄₈" (27mm x 48mm). They are in proportion to an 11" x 30" (28cm x 76cm) elongated rectangle, which can be used horizontally or vertically. Another shape you can use is 1¹⁄₈" x 3³⁄₄" (29mm x 95mm); it equals a 9" x 30" (23cm x 76cm) piece of watercolor paper.

The Golden Mean: locating the center of interest

Not all artists use the principles of the golden mean. Some feel that it is not necessary for the success of their painting. I, however, think this is a very valuable theory that I practice in my paintings. From my earliest study, I was introduced to the idea of having a center of interest. This theory had always intrigued me and after taking a workshop with Betty Lou Schlemm many years ago, I became very aware of the fact that inside every rectangle there is a square and inside every square there is a rectangle. That was one of those "Aha!" moments. I went further and found the seven unequal spaces within the picture space that are characteristic of the *golden mean*.

Study the examples on page 25. You will come to the conclusion that figures one through four accomplish the same thing, but each with a different approach. The difference in my approach is that it shows you how the picture space is broken into seven unequal shapes and that placing the focal point near the center, but not in the center, works by creating visual tension.

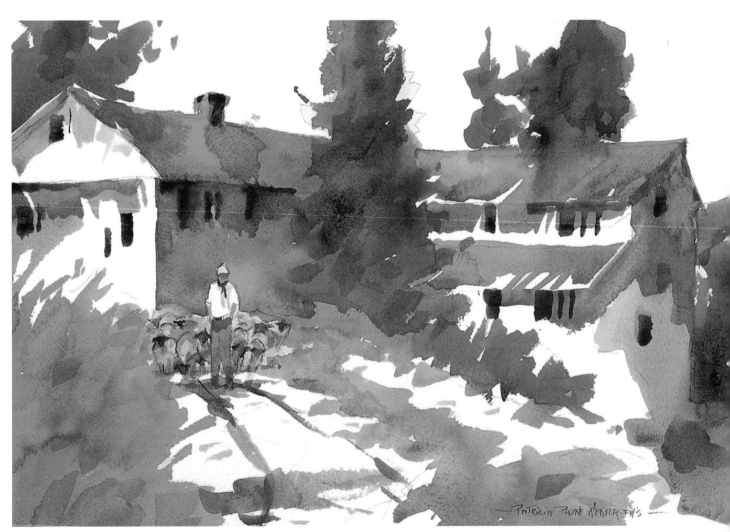

Finding the Center of Interest
Here is a study, which will be used for the final painting of the *Sheepherder*. Notice how I have used the principles of the golden mean to determine the center of interest. This foolproof method has been used for centuries. Visually, the picture plane has been broken up into seven unequal parts. We will go over this method in depth on pages 26 and 27.

Study for Sheepherder • *11" x 15" (28cm x 38cm)* • *Collection of the artist*

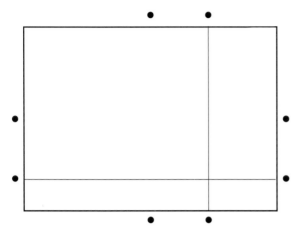

Figure 1 Four Rectangles

In this approach, the rectangular paper is divided into four unequal rectangles. The center of interest is where the two lines intersect.

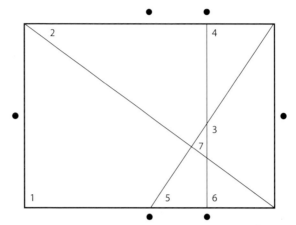

Figure 2 Seven Unequal Spaces

This is how I divide the picture space most often. The rectangle is divided into seven unequal spaces.

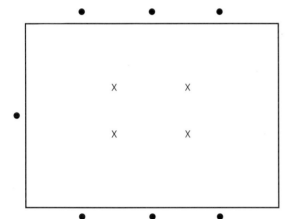

Figure 3 Standard

The focal points are marked with *X*'s. This shows that there are four possibilities for a center of interest, but only one is selected.

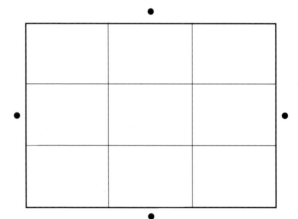

Figure 4 Rule of Thirds

The rule of thirds is another popular compositional convention. If you divide the horizontal and vertical sides of the paper into three equal parts, the intersection points give you the placement for your center of interest.

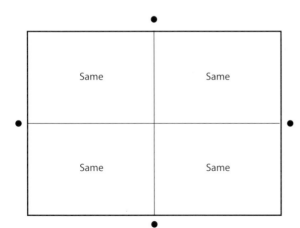

Figure 5 Don't Do This!

Do *not* do this. If you place your center of interest in the dead center of your paper, visually it divides the painting into four equal parts, making a very boring and static painting.

Placing the center of interest too close to the edge or too near the corners leads the eye out of the painting rather than allowing the eye to travel through the painting. If your painting is busy all over, there will be no focal point and the eye will become confused and quickly tire of this painting.

Using the Golden Mean to locate the center of interest

materials

Paper • Pencil

How do you find the right spot for the center of interest? We usually have some idea of what we want the center of interest to be. It could be a person, an animal, a building, a certain flower in an arrangement or even one eye in a portrait. Whatever you choose for your center of interest, it should show the lightest light, the darkest dark, the richest, most intense color and the most detail.

Let's explore how to find the center of interest using the golden mean by following this easy step-by-step demonstration. In this example we will place the center of interest in the upper right-hand corner.

The star

I often tell my students that in a play, a movie or an opera, there is room for only one star. If you attend a play and everyone on the stage is fighting for attention, out-singing or out-shouting one another, it will more than likely be very nerve-racking. The same is true of a painting. Keep it simple with one center of interest placed in just the right spot.

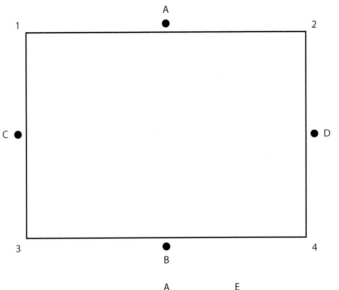

1 Mark the Center of Each Side
Place a dot at the center of the top (*A*) and bottom (*B*) edges. Then place a dot at the center of the left (*C*) and right (*D*) edges.

Decide which side of the paper you want your focal point to be, then you will be able to locate the square inside the rectangle. In this example, we will be placing the focal point in the upper right side.

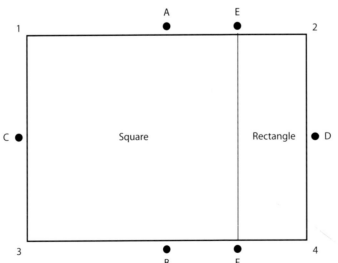

2 Find the Square and the Rectangle
Place a dot halfway between the horizontal center dots (*A*) and (*B*) and the right edge of the paper on both the top (*E*) and bottom (*F*) of your paper. Draw a vertical line between these two dots (*E* and *F*). The large rectangle is now divided into two unequal spaces that you can easily see. There is a square on the left and a rectangle on the right. The center of interest always lies on the inside edge of the square, never on the outside of the square.

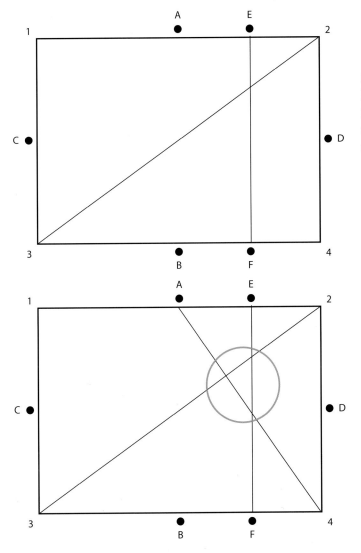

3 Draw a Diagonal

Remember which corner you want your center of interest to be in. In this example, the center of interest will be in the upper right-hand portion of the picture plan. You will always begin in the corner nearest to where your center of interest will be. Draw a diagonal line from the upper right-hand corner (2) diagonally to the bottom left corner (3). Now the picture space is divided into four unequal spaces.

4 The Center of Interest

Start on the same side as your center of interest but at the opposite (bottom) corner. Draw a diagonal line from the lower right-hand corner (4) to the top center dot (A). Now count the spaces. There are seven unequal spaces. This formula visually breaks the large rectangular space into seven unequal smaller spaces, which is interesting and pleasing—never boring.

The golden section is where the two lines drawn from the corners cross each other to form an X. Draw a circle around this X as shown to create the golden section. The center of interest can take up all of that circle or just some of it. The bigger the paper, the bigger the area for the focal point becomes.

Examples of the Golden Mean

S tudy these examples to see how I applied the golden mean to these paintings when placing the focal point and deciding on the center of interest.

Square

The center of interest is François's eye, located in the upper right on the inside edge of the rectangle. People instinctually look other people and animals directly in the eye. When painting people or close-ups of animals, make sure the most important eye is near the center, but not in the center.

François • *11" x 11" (28cm x 28cm)* • *Collection of the artist*

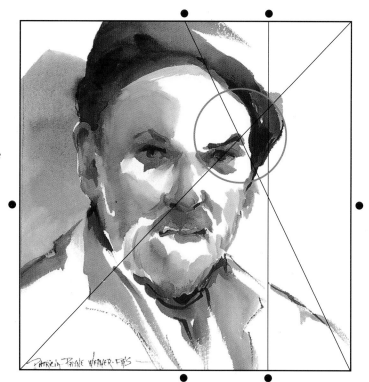

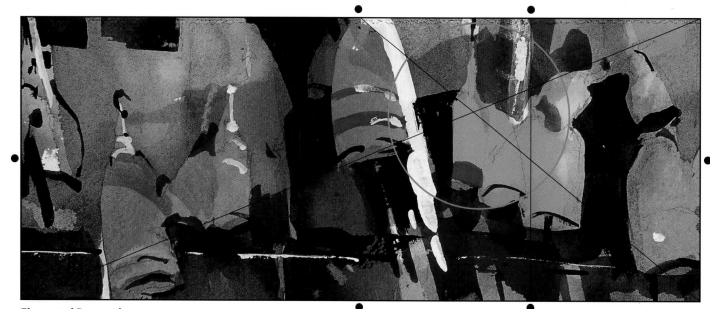

Elongated Rectangle

The center of interest is located in the upper right of the elongated rectangle. The extreme contrast between the light and dark values becomes the focal point.

Rockport Buoys • *5" x 12" (13cm x 30cm)* • *Collection of Alexandria Coulantes*

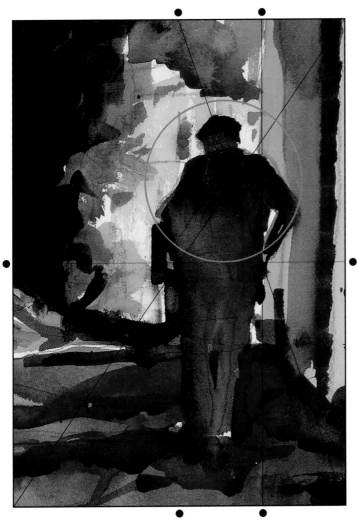

Vertical Rectangle

This center of interest is located in the lower right portion of the upper rectangle on the inside edge of the square. A vertical rectangle is two horizontal rectangles stacked on top of each other. Remember a horizontal rectangle has four possibilities for a center of interest. Because of the stacking, a vertical rectangle has eight possibilities, but you will only select one.

Strolling in Gordes • *15" x 11" (38cm x 28cm)* • *Collection of the artist*

Horizontal Rectangle

The center of interest is the two white daisies, located in the upper right portion of the rectangle. The focal point is always on the inside edge of the square.

White Daisies and Lavender • *15" x 22" (38cm x 56cm)* • *Collection of the artist*

Tip

Place the lightest light, the darkest dark, the richest, most intense color and the most detail at the center of interest.

Selecting the color temperature
for your painting

It is important to plan what color temperature your painting will have. Remember that opposites are interesting. We often hear the term push-pull or yin-yang—this means opposites. A painting that is half warm and half cool is boring and destined for failure. Before you begin to paint, decide what the dominant temperature will be. The painting should either be warm with an accent of cool, or cool with an accent of warm. Never half warm, half cool. Creating a painting with an even distribution of temperatures produces the same effect as dividing your painting into four equal parts—a very boring painting.

Warm

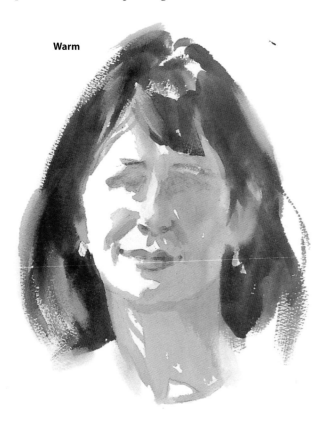

Cool

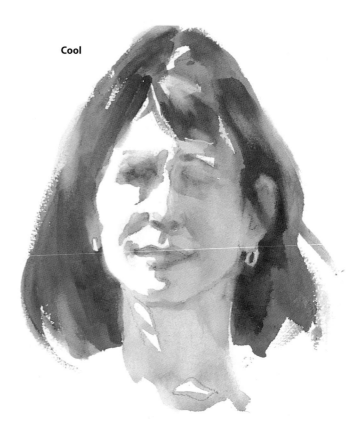

Warm and Cool Female
Both these paintings were painted very quickly, directly on the paper. Both are painted using only three colors—red, yellow and blue. The warm painting has a dominance of yellow/cool red with an accent of blue. The cool painting has a dominance of blue/cool red with an accent of yellow. Both paintings are interesting because they have a dominance of one temperature. Get the idea? Colors can be tricky. This cool red can swing either to the warm side or the cool side depending on the colors next to it. If this cool red is mixed with yellow, it produces yellow-orange, orange or red-orange. If it is mixed with blue, it produces either red-violet, violet or blue-violet.

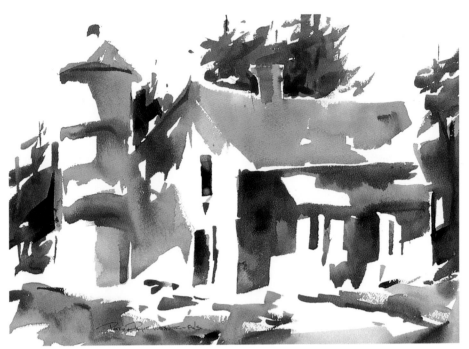

Comparing Warm and Cool Landscapes
Compare the warm painting with the cool painting. The same colors were used for both. The warm painting uses more of the yellow and cool red with an accent of blue to create a dominant warm feeling. Look what happens when the same blue is combined with the cool red with accents of yellow. The painting takes on a cool feeling when the dominant color is blue.

Warm

Barn • *15" x 22" (38cm x 56cm)* • *Collection of the artist*

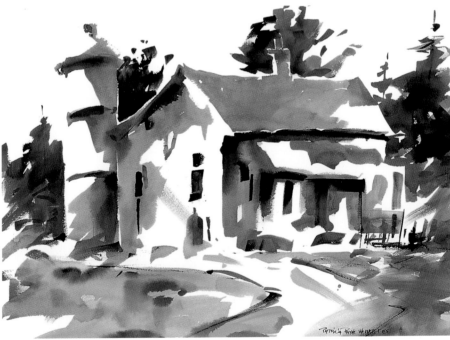

Cool

Barn • *22" x 30" (56cm x 76cm)* • *Collection of Steve Raston*

The process of planning the painting

Understanding the process of painting is crucial to success. Careful planning and foresight will help you avoid mistakes. Here are some helpful tips for setting up a painting:

* It is wise to become familiar with the subject matter before you begin a painting

* Gather your reference material for inspiration, details and subject matter

* Create a series of thumbnail sketches to determine your values and finalize your composition

* Complete a simple line drawing to determine the center of interest and locate the different shapes in your painting

* Select a color palette paying particular attention to color temperature

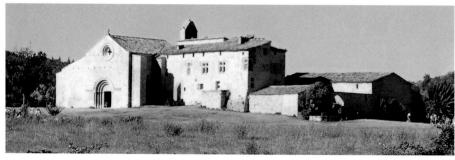

Reference Photograph

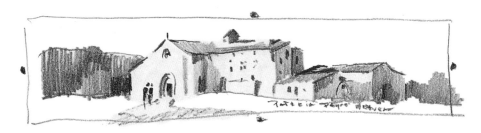

The Thumbnail

A small drawing of the subject done in any format that shows value is a thumbnail sketch. This can be very abstract with just three values—unequal portions of light, middle and dark values—or it can be more finished. Sometimes you will need to do several thumbnails using different formats until you are happy with the design and composition. This example was originally done as 1¼" x 6" (3cm x 15cm).

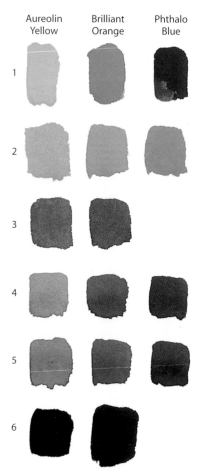

Selecting a Palette

For this painting, I chose a simple three color palette of Aureolin Yellow, Brilliant Orange and Phthalo Blue. Row 1 is the base palette. Row 2 shows yellow mixed with a little orange to make yellow-orange. Adding a little more orange to that mixture creates a middle value orange. And adding more red to that mixture makes a redder orange, but not as red-orange as Brilliant Orange.

Row 3 shows two grays—a warm and a cool. The warm gray on the left was mixed from Brilliant Orange and a little Phthalo Blue. The cool gray on the right was mixed from Phthalo Blue and a little Brilliant Orange. The ratio of water to pigment is crucial. The more water the weaker or paler the color, the less water the darker and richer the color.

I always mix my greens rather than squeeze them from a tube. Row 4 uses Aureolin Yellow plus a little Phthalo Blue to create a yellow-green. A little more Phthalo Blue added creates a green. Even more Phthalo Blue added to that mixture creates a blue-green. I did the same thing again for the greens in row 5, but this time I added one of the grays to each mixture, which grays down the greens.

The darks in row 6 are made with Phthalo Blue and Brilliant Orange. Brilliant Orange has yellow and red in it; when you mix a dark such as Phthalo Blue with a secondary such as orange it will create a dark you can use for black. The secret to getting a good dark is adding very little water to the mixture. We'll cover color mixing more thoroughly in chapter five.

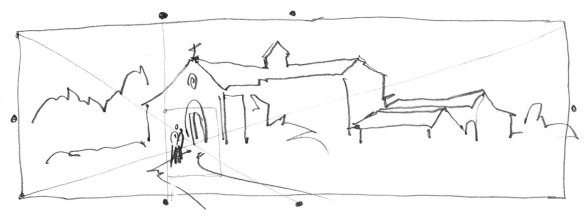

Simple Line Drawing

I use this step to determine the center of interest; no detail, just simple lines. It is not necessary to do a tight, detailed drawing on the watercolor paper for painting purposes, just a simple line drawing will suffice. Remember, that less detail is better.

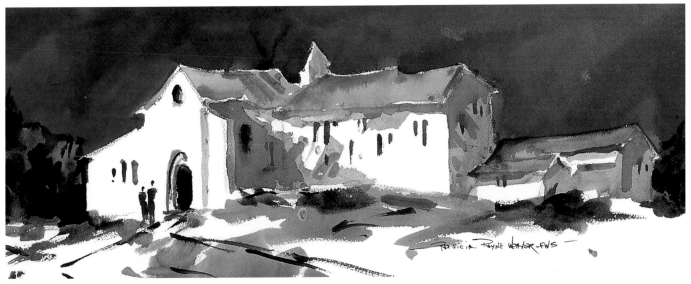

The Painting

This small painting has a complementary color scheme (orange and blue). I kept the sky dark and dramatic so that the white of the buildings and the orange roof would snap against the sky. I painted from the thumbnail, not from the photograph. Now if I want to paint a much larger painting than this, I have all the resources I need. I know where I'm going and how to get there. I can always vary this painting if I choose, but I have done my homework and now the chances are that the painting will be better. I've taken all the guesswork out of it. Just grabbing a piece of paper with no direction is planning for disaster. Know what you're going to do before you do it; have a plan and stick to it. You'll be surprised how much time and paper these steps will save rather than working by trial and error.

"A painting starts in the mind, and the mind has to have some sort of experiences." —Claude Croney

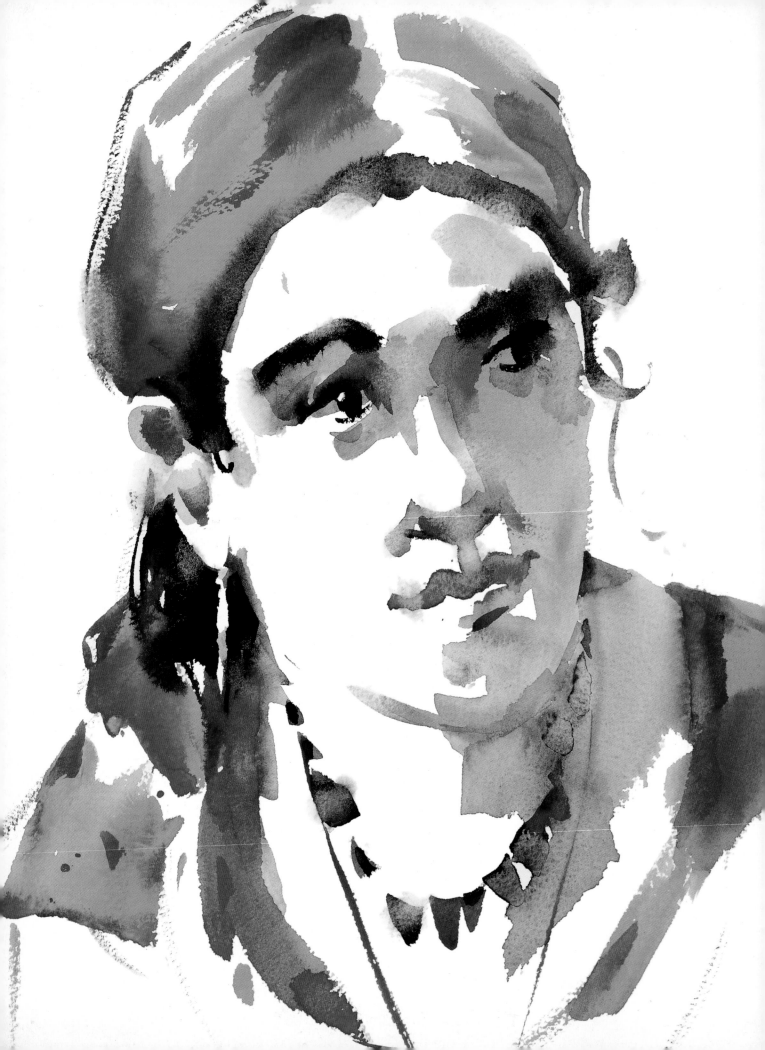

chapter three

drawing simplified

"I say and insist that drawing in company is much better than alone, for many reasons. The first is that you would be ashamed of being seen among a number of draughtsmen if you are weak, and this feeling of shame will lead you to good study; secondly a wholesome envy will stimulate you to join the number of those who are more praised than you are, for the praise of others will spur you on; yet another is that you can learn from the drawings of those that do better than yourself; and if you are better than the others, you can profit by your contempt for their defects, and the praise of others will incite you to further efforts."

—*Leonardo da Vinci*

This wonderful quote from Leonardo was passed to me. Everything that's said is so true and I want to share it with you. Don't ever be afraid of drawing. It is your best friend in painting. Learning how to draw is just a matter of training your eye to see and measure what is really there, not what you *think* is there. So often, a student looks at something, but doesn't really *see* it. Because of that, the wrong shape is put down or there is a drastic error in judging distances from one point to the next. The first line or mark placed on the paper is important because every mark or line that follows is related to the first one. I never erase, I just draw over, starting with a fairly light line and as I become more confident and sure of my drawing, the lines become darker.

Students often ask "Where do I start?" My answer is, begin drawing near the center of the paper, but not in the center and never at an edge. The focal point is usually a good starting point. Try to see the large shapes first, then break these shapes into middle-sized shapes and then go on to the detail, which is usually the smallest shapes. The detail should come at the finish, not at the beginning.

In this chapter we will look at value scales in pencil. You must understand value and how it applies to drawing as well as to painting. No matter which medium you work in, the principles are the same. To create successful drawings and paintings, it is essential to have at least three values: a light, a middle and a dark, in unequal proportions.

We will cover several approaches to drawing; the silhouette, the distilled drawing and the continuous dot-to-dot line drawing. You will learn how to draw upside down from a photograph. There are examples of drawing with a pencil, felt-tip pen, and pen and ink. There are examples of linkage—a powerful part of pulling a painting together—and how best to discover it. A solution to taking a small thumbnail sketch or a photo and scaling it up to a larger piece of paper, while keeping the exact same shape, is provided for you. You see a very simple approach to introducing figures into your architectural or landscape works.

A Chance Encounter • 22" x 15" (56cm x 38cm) • *Collection of the artist*

Value scales in pencil

The simplest and most effective way to learn about making a value scale is to work in pencil. A value scale done with paint will be shown in chapter four.

To create a value scale, draw nine squares vertically, numbering them 1 through 9. Identify 1 through 3 as light, 4 through 6 as middle, 7 through 9 as dark. The first square, no. 1, will be left white paper. Lightly shade the number 2 square making only vertical strokes using the pencil. There is much more power in a vertical stroke compared to using your pencil in a round and round motion or scribbling back and forth.

The objective is to make each successive square just a little bit darker than the previous one, so that when you get to the last square, number 9, it will be the darkest. You will always be comparing one square to the square above it. If you cannot see a definite contrast between squares, do not continue until there is one. Begin using the pencil lightly, applying more pressure as needed for each successive square. As you reach numbers 7 through 9, you will need to go over each square with the pencil several times to get them dark enough.

I begin most of my paintings with a middle value of number 4 or 5 against the white paper. Any value less than a number 4 or 5 is too light; there won't be enough contrast against the white paper. If you squint at white paper that has only been painted with a number 2 or 3 value, the colors will disappear.

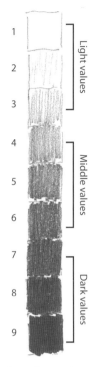

The Value Scale
Nine values are all that is necessary to create a value scale. Beginning with the number 1 value, which represents the white paper; numbers 2 and 3 are light middle values; numbers 4, 5 and 6 are the middle values; numbers 7 and 8 are the dark middle values and number 9 represents the darkest dark.

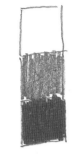

Full Range
These value scales train your eye to recognize contrast and to understand what high-key, low-key and full-range values are. Notice how each small scale relates to the larger value scale. It is only necessary to have three contrasting values in a painting to make it interesting, especially from a distance. Using more than three values gives you more options when painting and allows you to vary the amount of detail and interest.

High Key
High-key value plans have mostly light values and create an open, airy feel.

Low Key
A low-key value plan is mostly dark and can give a moody, brooding feeling to your painting.

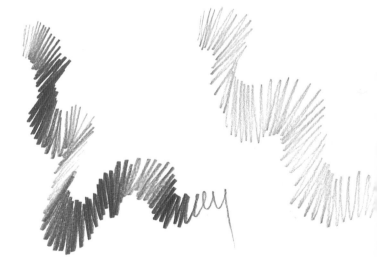

Value Ribbon In Pencil
Try creating a value ribbon by applying different amounts of pressure to the pencil—light pressure for light values, medium pressure for middle values and heavy pressure for the darks. Vary the length of the strokes and the rhythm of the scale. This exercise will help you in painting grass, fur on animals, skin, clothing, etc.

Silhouette drawing

Silhouette drawing represents the big overall outside shape of the subject you are attempting to draw. This is the first step when doing a contour drawing. The next step breaks this very large shape into middle sized shapes. Since my paintings are painted directly, I rarely draw anything other than the large and middle shapes. If I were doing a more finished drawing, I would break the shapes down into even smaller shapes or details. No matter what the subject matter is the idea remains the same.

Reference Photograph

This photo was taken while teaching a workshop in France. The subject was oblivious to me while I concentrated on his café and newspaper. The zoom lens comes in handy for this type of photograph.

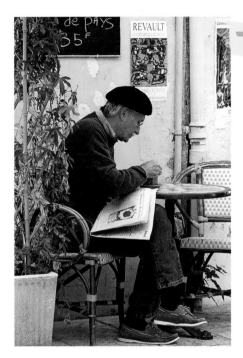

The three bears

The late Ed Whitney referred to shapes as Papa Bear, Mama Bear and Baby Bear. I remember his demonstration using facial tissues, which was intended to make the class remember the importance of big, medium and small. He placed a whole tissue on top of his head, stuck half a tissue in his ear and dangled a little tiny piece from one of his nostrils. What a funny sight that was. I never forgot what *Papa*, *Mama* and *Baby* meant after that. Mr. Whitney used some rather unconventional teaching methods, but they made lasting impressions. I believe he was truly a master teacher.

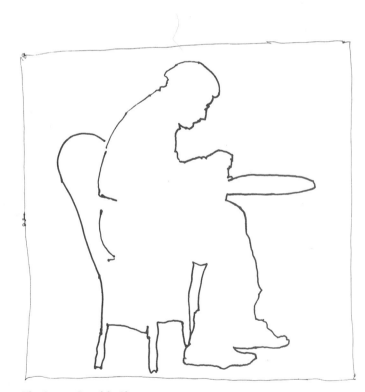

The Large Outside Shape

Draw the big outside shape to first simplify this otherwise challenging subject.

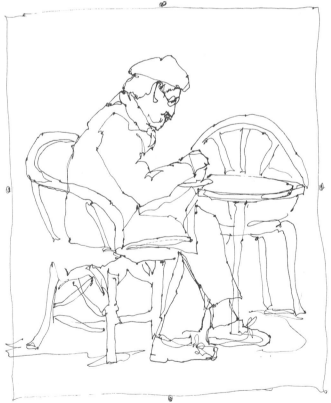

The Middle Shapes

The drawing was enhanced by going inside the big shape, breaking it down into smaller pieces, eliminating anything that I did not need for the success of the drawing. Keep in mind, the simpler the drawing, the better. We are sketching for painting purposes, not for a highly finished, detailed drawing.

Silhouette drawing

materials

Paper • Pencil

For a painting, drawing the large (*Papa*) and medium (*Mama*) sized shapes are as much as I would want on the watercolor paper. The less detail, the less inhibited you will be when painting. I would refer to the detailed drawing (*Baby*) in step three as an aid in painting the flower arrangement. Follow these easy steps to learn how to create a silhouette drawing by breaking a reference photograph down into its basic shapes.

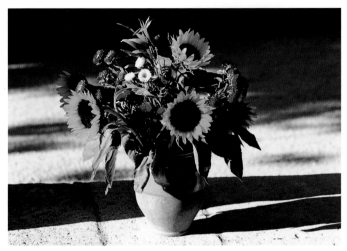

Reference Photograph

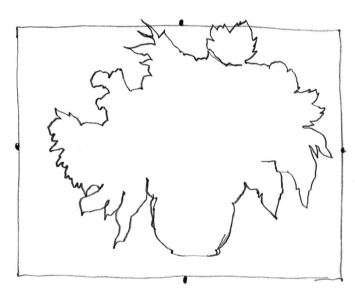

1 Draw the Big Outside Shape
Keep the photo in your hand as you draw so that you can easily see the shapes. Carefully follow the contours of the arrangement with your eye and use a pencil to draw the outside shape of the floral arrangement.

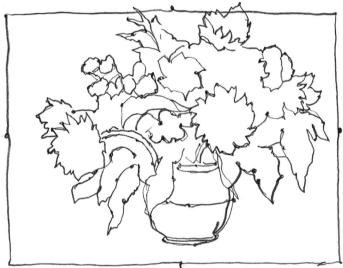

2 Draw the Medium Shapes
Now draw the shapes inside the contour line drawing, finding the middle-sized flower and leaf shapes.

3 Draw the Small Shapes
Now break the middle-sized shapes into smaller, more detailed shapes to finish the drawing. (See page 95 for a complete step-by-step direct painting demonstration of this drawing.)

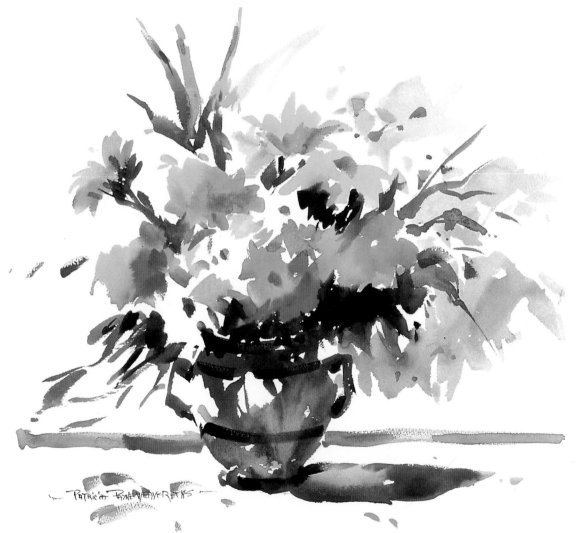

Fleurs La Bastide
5" x 15" (13cm x 38cm)
Collection of the artist

Distilled line drawing

A distilled line drawing is similar to the silhouette, but is usually done in three or less strokes. The goal is to capture the subject in as few gestural strokes as possible without losing its essence. The drawing should be fluid and graceful and is often used when working with figures. Study these two pages. See if you can follow the simplicity of the lines.

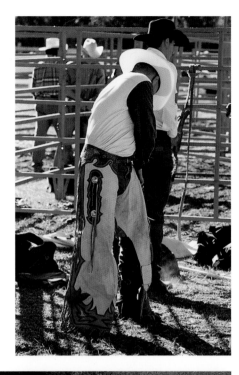

Reference Photo for *Cowboy*
The painting of the cowboy is another complicated subject that is simplified in two steps. The lighting and the cowboy's body position captured my attention.

Distilling a Subject
This drawing of *Cowboy* was done in three simple strokes of the pencil, beginning with the hat. The second line goes from the hat to the leg on the left side and the third line goes from the hat to the leg on the right side.

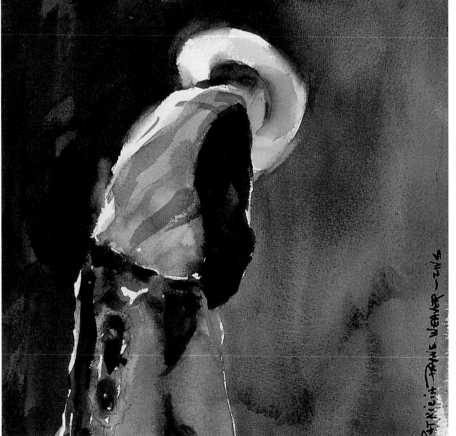

Completed Painting
The distilled drawing of the cowboy was used as a reference for this painting. My intent is to pull the viewer's eye to the brightest part of the cowboy's hat, so I simplified the background. After I finished the painting, I decided to crop it to a square format. Cropping is sometimes necessary to improve on the finished painting. The goal is to stay with the planned format, but if cropping will make an average painting into a smashing painting, then do it.

Cowboy • *11"x12" (28cm x 30cm)* • *Collection of Eloise B. Fritz*

Distilled line drawing

materials

Felt-tip pen • paper

I wanted to capture the body language in three simple lines. The subject is relaxed and makes an interesting pose. I used a felt-tip pen to complete this drawing.

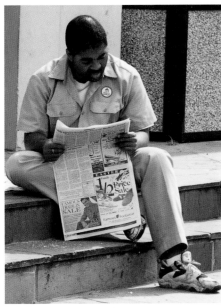

Reference Photo for *The Morning News*

1 The Head
Use one quick stroke to form the head.

2 The Right Side
Another stroke for the shoulder and left leg completes the right side.

3 The Completed Drawing
And one last quick stroke forms the right shoulder, leg and shoe.

Dot-to-dot continuous line drawing

I am not a proponent of using the grid transfer system, rulers or projectors for drawing. I consider these things to be crutches and harmful rather than helpful when learning to draw. Your eyes, brain, hands, paper and pencil are all that you need. Dot-to-dot continuous line drawing and silhouette drawing are the two methods I use most often. The dots are a way of measuring as I am drawing and are placed before the lines are drawn. They represent either where there is a change in angle or measure the distance from one point to another. In other words, I start with a dot, measure with my eye, place another dot then draw a line to connect the dots and so on until I have completed the drawing. This drawing method actually goes very fast and greatly shortens the amount of time invested in drawing your subject.

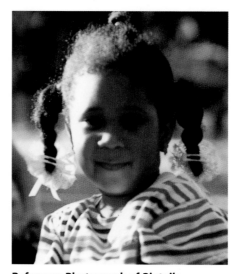

Reference Photograph of *Pigtails*
I took this photo over fifteen years ago and have painted this little girl many times.

Drawing of *Pigtails*
I used pencil to complete this dot-to-dot continuous line drawing.

Drawing the face

Study the examples given and see if you can see the changes in the line and where the dots are placed. When drawing a face, I almost always begin with one eye, then the nose, going down to the mouth. Then I will draw the other eye and both eyebrows. The next stage is the chin and the hairline above the brow. As you can see, this completes the face. Then I start drawing the outside of the face, including the ears, the neck and hair. If you draw the outside first, it's likely that the face will not fit. Draw the face first, getting it proportionately correct and then you can easily find the outside lines of the head.

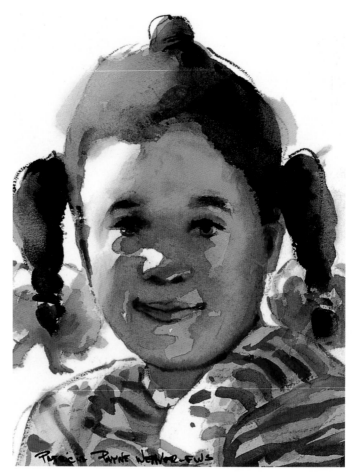

Helping My Painting
The dot-to-dot continuous line drawing made it easy for me to complete this painting. Because I had such a good drawing I could focus on the color— my main emphasis when painting—making it much more than it really is.

Pigtails
14" x 11" (36cm x 28cm)
Collection of the artist

Reference Photograph for *Curator of the Salvador Dalí*
This gentleman was a dapper, suave fellow who was fun to draw and paint.

Dot-to-Dot Drawing
The gentleman's glasses, beard and dapper dress made for an ideal dot-to-dot drawing. Any subject with a lot of interest can easily be rendered using this technique.

Measure carefully

Be sure to measure with your eye, vertically and horizontally. As you are drawing, ask yourself the following questions: Where do the subject's ears line up horizontally? Is the bottom of the ear horizontally level with the top of the lip, the bottom of the nose or in between the lip and nose? Does the top of the ear line up horizontally with the top of the eyebrow or with the top of the eye? Is the space between the eyes exactly one eye width? Does the nose line up vertically with the inside of the eye? How much space is there from the bottom of the nose to the top of the lip? See, it's all about measuring.

Do you know that the eyes fall in the center of the face from the top of the head to the bottom of the chin if the face is straight, not tilted, leaning forward or leaning back? If you get the nose the right length, the outside corner of the eye, the nose and the inside corner of the eye form an equilateral triangle. If the nose is too long, which is often the case, you will have an isosceles—two equal sides and one unequal side—triangle instead. An isosceles triangle elongates the nose, making it look too long and very wrong.

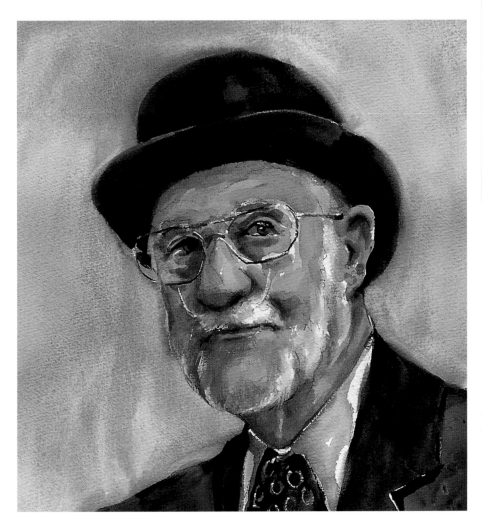

The Finished Painting
The painting was not copied slavishly from the photograph. The juicy color is much more intense and more loosely painted.

Curator of the Salvador Dalí • 20" x 16" (51cm x 41cm) • *Collection of Mr. and Mrs. Al Heiler*

John Seerey-Lester, dot-to-dot

John Seerey-Lester is a noted wildlife artist whose work I have admired for many years. His knowledge of animals and drawing skills are so honed that he paints their silhouette shapes on the canvas without a tight, laborious drawing.

He develops his paintings using a loose, juicy approach. He knows the anatomy and environments of these animals right side up, upside down and in his sleep. I'm sure he would tell you that it took many years of study and practice to work in this manner. John is truly one of the most outstanding, living wildlife artists of our time and it's a privilege to know him.

Continuous Line Drawing
I enjoyed doing this continuous line drawing of John. My total drawing time was three minutes.

Detailed Drawing
This is the second drawing of John, a more finished one, showing light and shadow. This more detailed drawing took me twenty minutes to complete.

"Like your signature, your own painting style will come through." —Claude Croney

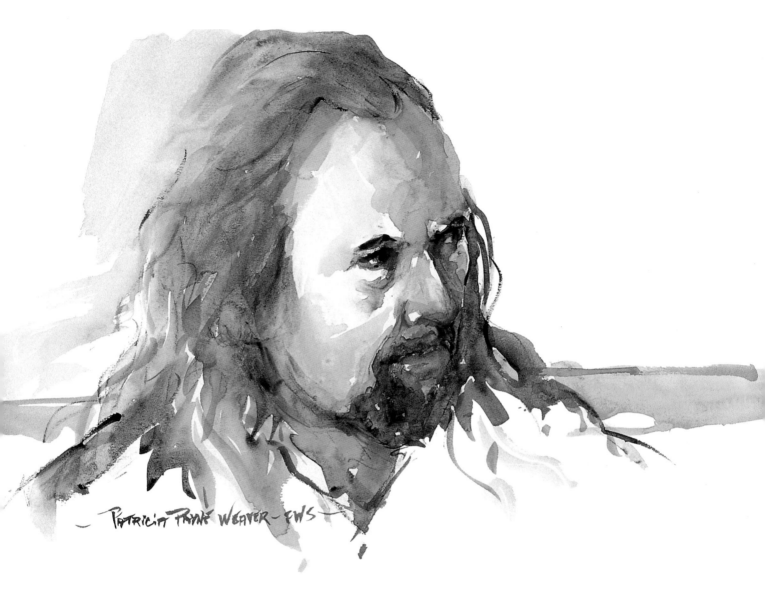

Direct Painting

By the time I had drawn John several times using different approaches, I was familiar, comfortable and confident to paint him directly without drawing on the paper. This happens to be my favorite approach to painting; but I always do my preliminary work first. I always follow this process: thumbnails, value sketches or black-and-white value paintings, continuous dot-to-dot line drawings, working up a color palette and then painting directly. This may sound like a lot of time spent on drawing and planning, but all of the preliminary work takes less than one hour and is time well spent preparing for the final painting.

John Seerey-Lester • *15" x 22" (38cm x 56cm)* • *Collection of the artist*

Upside Down Drawing

materials

Pencil or felt-tip
pen • Paper

Drawing upside down forces you to look at the shapes, rather than the likeness of the person. If you measure accurately and get the shapes correct, when you're finished you should have a relatively good likeness of the subject. Do not jump around or you'll lose your place and concentration.

You want to create a continuous line drawing. Begin with the inside of the face. After finishing the inside of the facial features, move to the outside of the face. This would include the ears, hair, jewelry, neck and clothing.

When you begin the drawing process, be sure to hold the photograph upside down in one hand, concentrating very hard on the shapes as you draw.

Fear not!

The only thing you have to fear is fear itself. The more of these exercises you do, the better your drawings will be and you're going to feel so good about yourself. Little successes are wonderful and coupled together they begin to add up to big successes and much improved paintings.

Reference Photograph
This model has good strong features and the photograph was taken in bright sunlight. The head is positioned so that the shadow shapes are linked and very easy to see.

1 Draw the Inside of the Face—Upside Down
Hold the photo upside down in your nondrawing hand. Begin with the chin and draw a linking, continuous line moving up to the lower lip, making sure to include the shadow shapes as you go. Move from the top lip to the flaps and nostrils of the nose.

2 Finish the Inside of the Face

Continue to work on the inside of the face. Draw one eye, carefully measuring with your own eye to be sure that the eye lines up with the nose, and then the second eye. Include the eyebrows. Measure the distance for the forehead, hairline and then move to the outside shape of the hair, face and one ear.

3 Complete the Drawing

Complete the shapes for the hair, then move down to the neck area, shoulders and clothing. Don't forget those all important shadow shapes on the neck and shoulders.

Right Side Up

The same reference photograph was used to complete this drawing, this time drawn right side up. There is actually very little difference in the two drawings, both have character and look like the model.

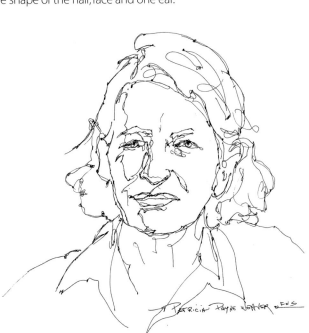

"Quite often the thing you draw first for your painting will be the last thing you actually paint." —Claude Croney

Linkage of dark and light, a simple way to see

The quickest and simplest way I have found to teach my students to understand the linkage of lights and darks is the following simple exercise.

Select a photograph that has extremely good light and shadow in it, such as the one shown. Make a good quality black-and-white copy enlarged on a quality photocopier. Take the black-and-white photocopy to a window that has bright light shining through it or to a light box. Tape the copy to the window; place a piece of white copy paper over the image. Shade anything that appears to be middle, low-middle or dark value with a 6B pencil. Don't shade anything that appears to be white or a value below a number 4.

Squint as you are working to simplify the shapes. With your finger, follow the linking patterns of the dark shapes. Then follow the linking patterns of the light shapes. The linkage or patterns should travel through the drawing and not be trapped or isolated. In other words, there should be no great jumps between the shadow patterns. Thus the word linkage becomes obvious.

Linkage is extremely important and valuable for an artist to understand. Your eye naturally links values—all the light and middle-light values are linked together and all the middle, middle-dark and dark values are linked. It's a natural occurrence. When the eye becomes trained to recognize these connections, there is more continuity to the painting and linkage provides a comfortable pathway for the eye to travel. Study the reference photo and the pencil sketch of *Rodeo Cowboy*. You will become more tuned into the linkage and automatically apply this theory to your painting.

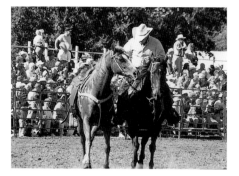

Reference Photograph for *Rodeo Cowboy*
The light was outstanding the afternoon this picture was taken and I was excited about the possibilities in developing this as a painting. I simplified the background and located the linkage with my drawing.

Value Creates Linkage
A 6B pencil was used for this exercise. The three values are easy to read: the biggest shape is the light value, the middle-sized shape is a middle value and the smallest shapes are the darks.

Rodeo Cowboy • 8" x 8" (20cm x 20cm) • *Collection of the artist*

Reference Photograph for *Woman Model*
This is another excellent example of light and shadow patterns. If you squint, you see less detail.

Linking the Values

I used a 6B pencil and used vertical pencil strokes to shade the eye sockets first. I then moved down to the nose placing the shadow under the nose, shading the top and bottom lips, shadowing under the lip on the chin and then down to the neck and shoulder. The eyes were then placed into the eye sockets. The shape of the hair was the last to be considered and shaded with the pencil. Note that there are three definite values in this exercise: the light value is the biggest shape, the middlevalues are the medium-sized shapes and the dark values are the smallest shapes. There is virtually no drawing of lines in this exercise, just a simple shading of the shapes with the side of the pencil.

A Finished Example

This is a more finished likeness, but uses the same principle of only drawing those shapes that are in the shadows.

Woman Model • *22" x 15" (38cm x 56cm)* •
Collection of the artist

Simplifying figures

Three shapes are all that is required to draw simplified figures. A horseshoe shape for the upper body, an oval for the head and an elongated *W* for the hips and legs. At first your figures may look a little stiff, but as you practice, try making them more lyrical and graceful. Be sure not to make the heads too big. The head should be relatively small in comparison to the upper body. Leave space between the head and the shoulders to represent the neck. Study the examples given. See how many different ways you can draw your figures. Look in magazines and at photos for subjects to draw. Try groupings of people.

Study the perspective of groups of people. Notice how all of the heads stay fairly level, but as the figures become smaller, the legs appear to be shorter. This creates distance and leads to a vanishing point.

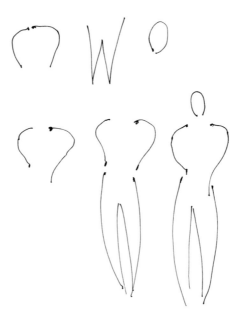

Simple Shapes
A horseshoe, an elongated *W* and an oval is all you need to represent the figure. This is gesture drawing at its simplest. Draw the upper body with the horseshoe shape, add the elongated *W* for the legs and the oval for the head.

Simple Poses
Try some figures in action, seated, bending or making some other type of movement.

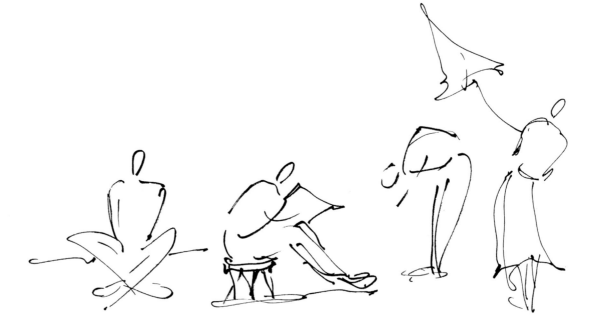

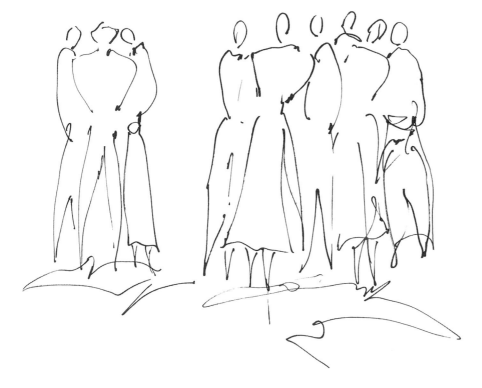

Simplifying Groups of People
Try some figures in groups. Notice how narrow the horseshoe shape becomes when the figures are turned to the side.

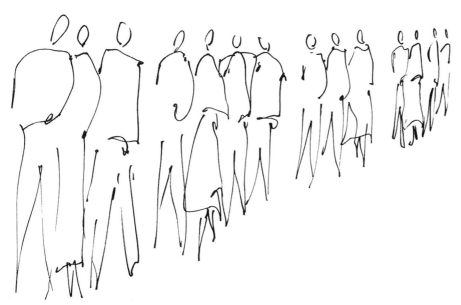

Creating Distance
Try drawing some figures standing in line. See how the heads stay level, but the legs and bodies become smaller as they recede. This creates the illusion of distance.

Scaling Up a Thumbnail

materials

36-inch (91cm) straightedge • Half sheet of 140-lb. (300gsm) watercolor paper • Pencil • Thumbnail sketch or reference photograph

It is much easier to work out your design and compositional problems on a small piece of paper or thumbnail sketch. A lot of time and paper can be wasted drawing directly on the watercolor paper without giving any thought to what you're trying to accomplish. But once your thumbnail drawing is successfully completed, how do you make it work on a larger piece of paper? How do you know what size paper to use? Easy, no mathematical equations needed, just a pencil and a straightedge.

Whatever format you choose for the thumbnail—horizontal, vertical, square or elongated—you must stay with the exact format for the painting. The drawing on the thumbnail will not work on differently shaped paper. The scaling up method will show you how to determine the exact dimensions of the paper you need to create your painting. This method can also be used for scaling up photographs.

1 Align the Drawing
Scaling up an image is really very easy. Place the thumbnail drawing or photo in the bottom left-hand corner of your watercolor paper. Be sure that the drawing or photo is even with the left outside edge and bottom edge of the paper.

2 Place the Straightedge

Place a straightedge so that it creates a diagonal line from the outside corner to the inside corner of the thumbnail and continues onto the watercolor paper. Draw a line through the image along the diagonal created by the straightedge continuing on to the edge of the watercolor paper.

3 The Vertical Line

When the diagonal line reaches the edge of the watercolor paper, stop. Draw a vertical line from the edge of the paper down to the opposite (bottom) edge. This will recreate the exact shape of the original sketch or thumbnail. Now cut, tear or tape off the watercolor paper on this vertical line.

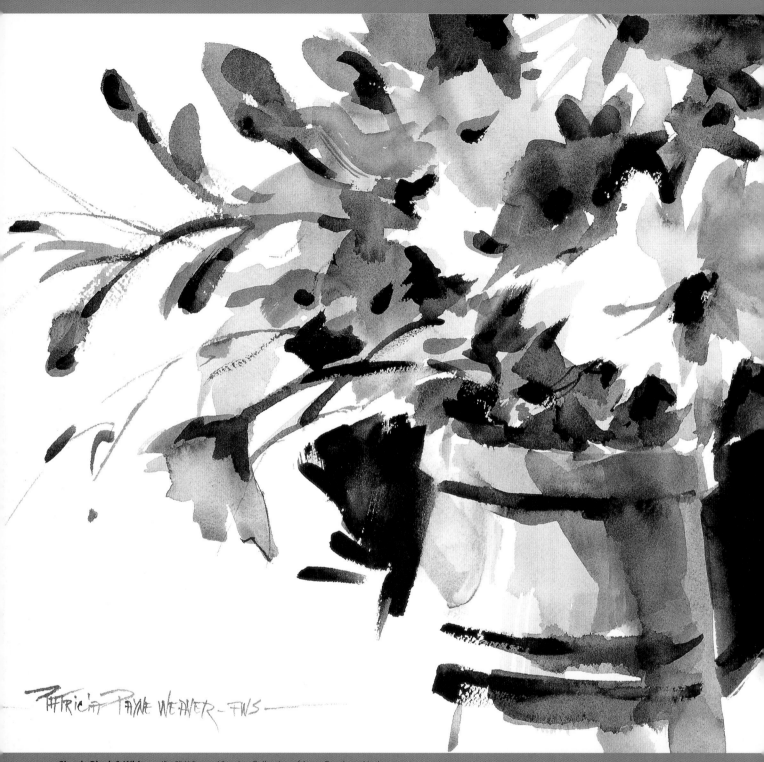

Simply Black & White • 4" x 5" (10cm x 13cm) • Collection of Anne Goodyear Hudnut

chapter **four**

value

simplified

Before we begin this chapter on value painting, here is a good, sound piece of advice for you: Don't skip this step of the painting process. You may be anxious to put paint on the paper and think that messing around with value sketches is a total waste of valuable painting time, but you are wrong. The two most common problems I encounter as a teacher are a lack of drawing skills and little or no knowledge of value. Students think that color is their problem when color is the least of their concern. For most students, technique is high on the priority list and the theory or principles of drawing and painting are way down on the list. So, I encourage you to switch your priorities, focusing on the building blocks of painting. Discipline will bring you success.

Understanding value

Painting becomes much easier when you have a good fundamental understanding of how to see and use value in your paintings. The term *value* simply means how light or dark a color or object is. In order to determine values, you must make comparisons.

This brings us to the word *contrast*. Contrast simply means a marked difference. It's one of the most important concepts in painting because contrast creates interest, and most beginner work doesn't have enough of it. White next to black is the most extreme contrast. In transparent watercolor, the white of the paper represents the lightest light, a number 1 on the value scale. Hang on to the white of your paper for as long as you can. Once it's gone, it's gone forever.

When determining the value of a color look for big shapes that are the same value, try squinting. Squint both eyes, so that everything becomes less detailed, more simplified not only in value, but in edges as well. I know that squinting produces wrinkles around the eyes, but vanity is not a consideration here. So, don't worry about that and squint. Be sure to squint only when you're looking at the subject—keep both eyes open when applying paint to paper.

Tip

Learn to do a lot with a little.

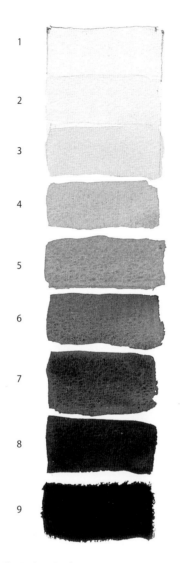

The Value Scale
Keep a value scale with you whenever you are painting. I used Peach Black to create this one. As discussed in the previous chapter on drawing, nine values are all that are needed—three lights, three middle values and three darks. Yes, there are many more values than nine, but it's not necessary to try and capture them all in one painting.

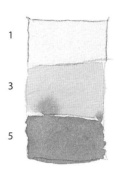

High-Key Value Plan
A high-key painting would be light and airy, without much contrast. All of the values are light to middle with virtually no darks in the painting.

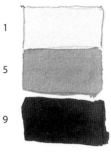

Full-Range Value Plan
A full-range painting has the most opportunity for contrast. It uses a wide range of values, from the very light to the very dark.

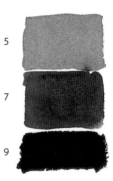

Low-Key Value Plan
A low-key painting will sometimes include a small amount of white paper and is usually somber, moody or represents threatening weather. Therefore, most of the values are middle, low-middle and dark.

A value study with strong contrast

Reducing a subject to its correct value relations is vital to good painting. Flat planes receive more light while vertical planes receive less light. Seek out the big simple shapes, use three values in unequal portions and apply the paint quickly in a loose and gutsy manner to produce exciting value studies.

Tips

Here are some tips I received as a student from artist Claude Croney:

✱ Cover the paper quickly, painting from top to bottom, back to front, large to small, focusing on large areas first.

✱ Start with large brushes; finish with small ones.

✱ A value painting or value study does not have to be large. Thumbnails are necessary to work out value relations and compositions, but they can be very small.

✱ Keep it simple.

✱ Keep in mind that when painting large from a small value painting, the larger painting should take on a life of its own, having the same spontaneity and freshness of the smaller one. It shouldn't be slavishly copied.

✱ Once you're happy with a value study, stay with the same format for the color version.

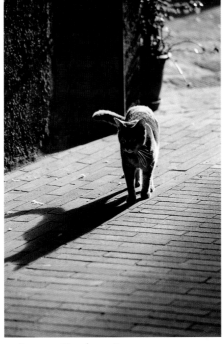

Reference Photograph
If you squint at this reference photograph, you can easily see the contrast of values.

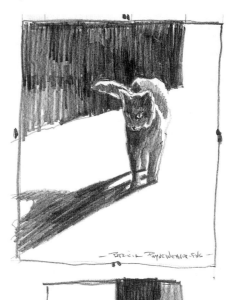

Pencil Study
This pencil study for *Monsieur Chat* uses big, unequal, overlapping shapes and three unequal values. The variations in value add contrast and create interest.

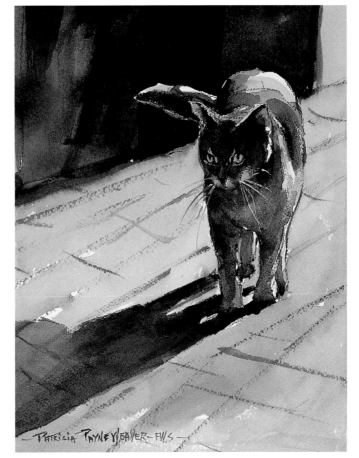

Final Painting
Monsieur Chat was painted from the pencil study. The white paper in the pencil study is now a light value of yellow, but it still reads well against the darks. I used a limited palette of Quinacridone Gold, Ultramarine Blue and Permanent Rose.

Monsieur Chat • *10" x 7" (25cm x 18cm)* •
Collection of the artist

A value study from a sketch

Paintings with low contrast can be used to create interesting moods. High-key paintings contain values that are found on the light end of the value scale— 1 through 5. These paintings are light and airy and could be described as friendly or welcoming. Low-key paintings are just the opposite. Their values are found at the dark end of the scale and range from 5 through 9. These paintings can be described as dark and moody.

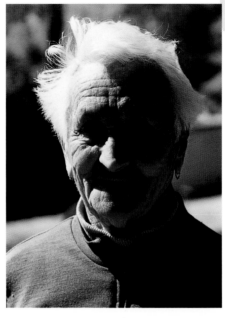

Reference Photograph
I became intrigued with this woman in Avignon, France, and asked permission to photograph her. Her face was weathered from the sun and showed great character making her a great subject for a painting.

Cropping
When the subject is too small for the size of the paper, it's like a little fish in a big pond. Once it's cropped, it becomes a big fish in a little pond. Don't hesitate to crop if it makes for a better painting.

Value Study
Once the large value pattern is established, whatever detail is applied to the painting doesn't change the painting that much. If the painting reads well at a distance in the early stages, then you're off to a great start and the detailed finish is only evident at close range. If a painting has a change of color but little or no contrast, it will be difficult to read at a distance.

High Key? Or Not?
At first glance this painting appears to be high key, but it has some good darks in it even though they are a very small portion of the portrait. The white of the paper represents the lightest value, the background and shadow shapes are middle values, and the accents and eyes represent the darker values.

Old Woman of Avignon
22" x 15" (56cm x 38cm)
Collection of the artist

58

A study with a full range of values

Early on, I was taught that every color has a value and every value a color. No two artists will see value or color exactly the same way and that's just fine as long as there is variation and contrast. It's very important to have a plan and that plan begins with a value study in pencil, pen and ink, felt-tip pen or a dark color such as Peach Black or Burnt Umber.

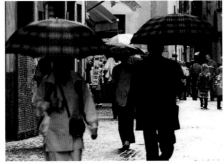

Reference Photograph

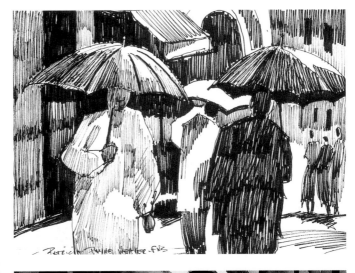

Value Study With Felt-Tip Pen

Value Study in Gray Tones
This is a value study taken from the felt-tip pen study. I painted it without drawing on the paper first. My intent here is to link all the lights and link all the darks, painting the interesting shapes of the umbrellas and people.

Using Your Sketches for Reference
I used a limited palette of Quinacridone Gold, Phthalo Blue and Opera. I closely followed the original felt-tip pen value study for this final painting because I liked the larger umbrellas and the very dark figure to the right against the smaller figure that I painted red.

Summer in Florence • 11" x 15" (28cm x 38cm) • *Collection of the artist*

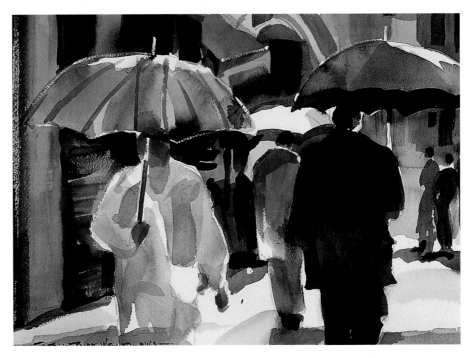

Value Painting from Photographs

materials

1-inch (25mm) angular flat brush • Burnt Umber watercolor paint • 11" x 15" (28cm x 38cm) piece of 140-lb. (300gsm) watercolor paper

Here is an example of a value painting in Burnt Umber. A value scale in three unequal portions is shown so that you can see how the *Papa*, *Mama* and *Baby Bear* theory applies. (See page 37.)

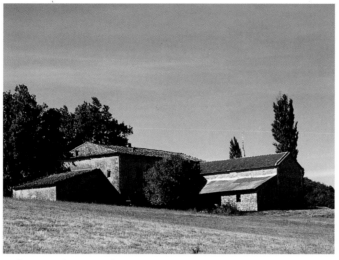

Reference Photograph
This photograph appears to be split in half because the tree in the middle separates the bright lights on the building. For this demonstration I will use a composition from the left portion of the photo.

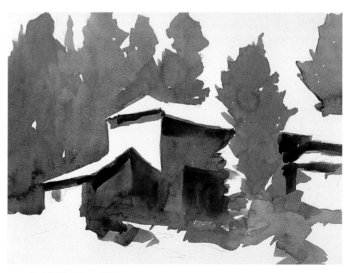

Painted Value Scale
Look at the correlation between this value scale and the actual finished value painting. The smallest piece in the value study is the dark (*Baby*). The largest piece is the middle value (*Papa*) and the middle-sized piece is the light (*Mama*).

1 Define Large Shapes
Squint at the photograph to see the connecting light and shadow. Use the 1-inch (25mm) angular flat to paint the big linking shadow shapes, including the tree, using Burnt Umber in a number 5 value. See how this value snaps against the white paper? You want the contrast to be very easy to read.

2 Add Darker Values
Paint the trees behind the building. Locate and paint the negative shapes to define the roofs of the structure. Even though the roofs have color in the photo, leave them as white paper. Paint with a number 7 value to show darker shadows under the eaves and to create a large door opening next to the tree. As you go darker, use less water and more pigment.

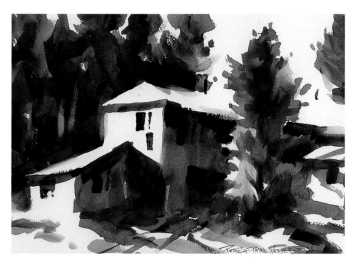

3 Add details

Apply a dark number 9 value on the white paper for the windows and for smaller darks throughout the painting. Make the windows a variety of shapes.

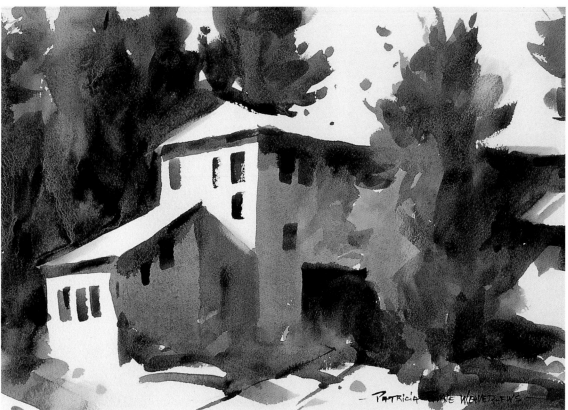

Using Your Value Painting

This painting was done from the value painting above. The palette I selected is a triad of Quinacridone Gold, Ultramarine Blue and Burnt Sienna. Notice the red in the window at the center of interest—a little trick to help draw your eye to that spot.

Le Français Grange—Cereste, France • *11" x 15" (28cm x 38cm)* • *Collection of the artist*

Tip

When painting, remember to follow these rules:

✻ Have a plan

✻ Follow through

✻ Stay focused

Value Painting From a Sketch

materials

1-inch (25mm) angular flat brush • Peach Black watercolor paint • 11" x 15" (28cm x 38cm) 140-lb. (300gsm) piece of watercolor paper

One of the most challenging aspects of teaching is convincing a student of the importance of doing value sketches or value paintings before working in color. Color *is* value. You squint to see value; changes of value produce contrast. Contrast of value in unequal portions (light, middle and dark) excite the painting. You must learn to use the value scale and then apply the scale to the development of your subject. Three contrasting values in unequal proportions painted simply can make a very bold statement.

This should be your thinking process and your road map to success. The value painting only takes minutes to do and saves a lot of time in the long run. It also helps to prevent grave errors and trashed watercolors. You will see how simply the values are handled in the following demonstrations and then used to create paintings using full color.

Tip

The ratio of water to pigment is very important. The lighter the value or color, the more water you need. The darker the value, the less water and more pigment you use. Very dark values or colors consist of virtually no water and are almost all pigment.

Value Scale

The dark is the largest piece (*Papa*), the white is the smallest piece (*Baby*) and the middle value is the medium piece (*Mama*).

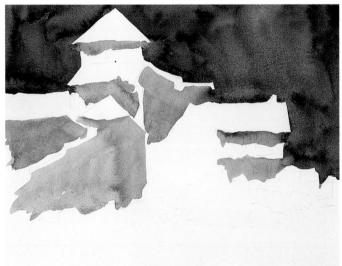

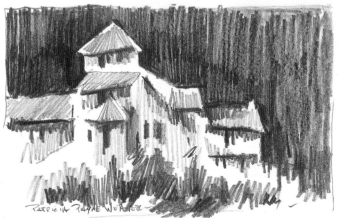

Pencil Study

This small value study was done in pencil. It is only 2" x 3" (5cm x 8cm) but it is the beginning of the thinking process and the basis for this painting.

1 Define the Large Shapes

Follow the small pencil study. Paint all the shadow shapes on the structure with Peach Black using a number 5 value. The dark contrast should snap against the white of the paper. Paint a number 8 value behind the roofs of the building to represent the background. You should be able to see the contrast with three values—light, middle and dark.

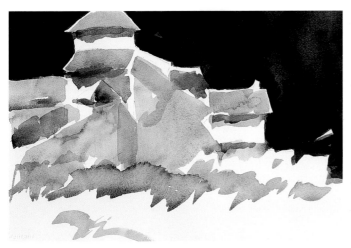

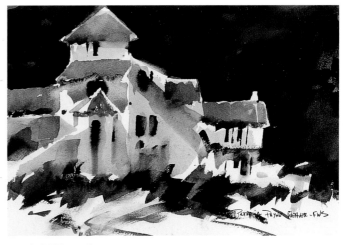

2 Darken the Values
Paint into the shadows with a dark number 7 value and then into the foreground with a number 5 value. The number 7 value begins to give the study a little more punch.

3 Add Detail
For the finish, darken the background to a number 9 value. Add windows for detail and darker values in the foreground.

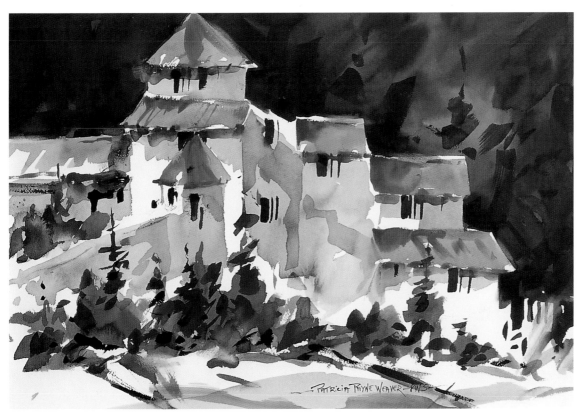

Painting in Color
I used a limited palette of Aureolin Yellow, Phthalo Blue and Opera. I painted directly from step 3 without any pencil drawing on the paper.

Spanish Villa • *15" x 22" (38cm x 56cm)* • *Collection of Marion McAdoo*

Using a Value Study to Create Variations

materials

No. 8 round brush • 1-inch (25mm) angular flat brush • Burnt Umber • 11" x 15" (28cm x 38cm) 140-lb. (300gsm) piece of watercolor paper

Nothing is less productive than having put absolutely no thought into how you're going to create your painting. This demonstration breaks each step down and makes you more aware of the allotment of the three contrasting values in unequal portions. A value study is monochromatic (one color) and can be any color, usually a neutral—Black, Payne's Gray, Burnt Umber or Burnt Sienna. It's difficult to do a strong value study with a light or middle valued color such as Aureolin Yellow, Yellow Ochre or Cerulean Blue. The darker color can always be lightened with water for different values. Value studies can be just as effective in pencil, pen and ink, felt-tip pen or charcoal as demonstrated.

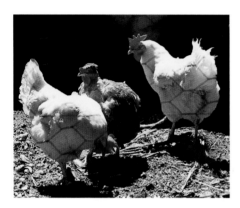

Reference Photographs
While painting on location, I watched these hens behind chicken wire. Once they felt comfortable with me, they came out into the sunlight and I photographed them.

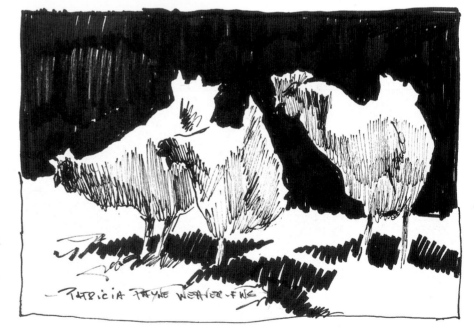

Value Study With Felt-Tip Pen
This is a composite sketch combining the two reference photographs. The value study shows the unequal portions of middle, light and dark. Dark is the biggest piece, *Papa*, white is the *Baby* and the middle value is the *Mama*.

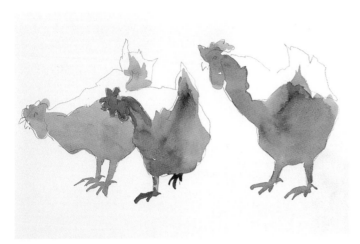

1 Paint the Shadow Shapes

Use a no. 8 round to apply Burnt Umber for the shadow shapes at a number 5 value. Use a slightly darker value for accents on a couple of the hens and on their feet.

2 Add the Darker Values

Paint the background a number 7 value. This makes the white of the hens' feathers snap. The backlighting on the hens creates this type of contrast.

3 Add Details

Darken the background using a deeper value of Burnt Umber. Add the shadow shapes under the hens and other details using a darker value. Remember, everything is a gradation on the value scale and the aim is to make the whites snap and sparkle.

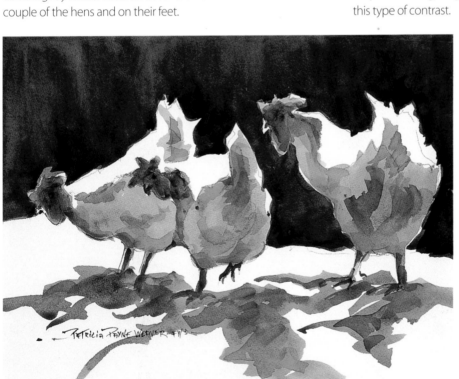

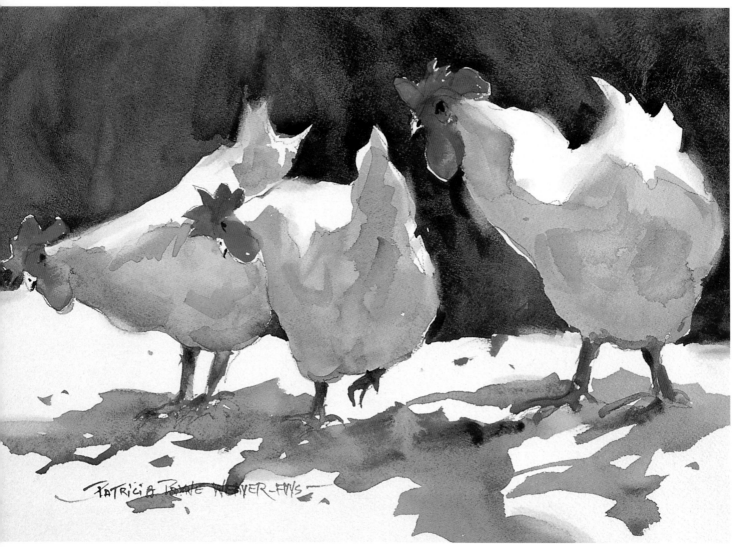

A Warm Painting From the Value Scale
I used a limited palette of Aureolin Yellow, Quinacridone Gold, Opera and Ultramarine Blue. The rich reds were made using Aureolin Yellow and Opera. I used step 3 of the value study as a reference and pushed the painting to the warm side.

Three French Hens • *11" x 15" (28cm x 38cm)* • *Collection of the artist*

"Always leave some white paper so you can later determine how far you can go with the most important values." —Claude Croney

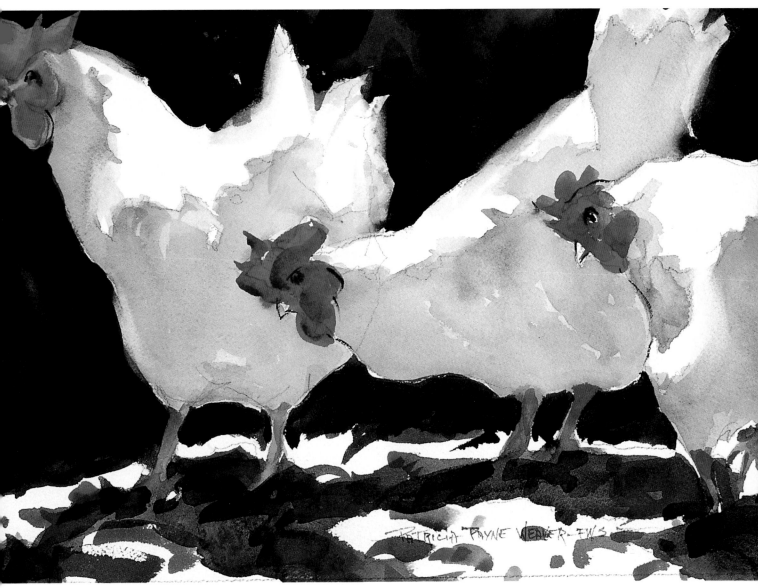

Pushing to the Cool Side

I used the same palette and the same hens with a different composition to push this painting to the cool side. I have created a totally different feel by slightly altering a few elements—rearranging the composition to create new shapes, using a cool palette and increasing the contrast.

Variation of the Three French Hens • *11" x 15" (28cm x 38cm)* • *Collection of Linda Beaulieu*

chapter five

color simplified

Color can be simple or it can be quite complex. I will demonstrate how to simplify color choices with limited palettes and triads that make using color an exciting and enjoyable experience. I'll try to give you the fundamentals you need to know and how to use them.

In 1980, I purchased *Nature's Basic Color Concept* a book for oil painters by artist, Merlin Enabnit (Midwest Advertising Service: Des Moines, 1975). This little book was very thorough in its explanation and application of color theory. My medium at that time was oil, but I have since adapted his color theory to my watercolor paintings. Merlin is no longer with us and his book, unfortunately, is no longer in print. However, I still consider his writings and demonstrations a treasure and continue to implement his color theories.

Being an oil painter, Merlin used white paint in his mixtures. When painting with transparent watercolor, I don't use white paint. I'm what is known as a purist; the white of the paper is used instead of white paint. Water takes the place of white paint for lightening or tinting a color.

Red Silk Scarf • *22" x 15" (56cm x 38cm)* • *Collection of the artist*

The basics of color

Color can be simple or it can be very complicated. There are many formulas for mixing and so many terms that it becomes overwhelming. So, let's see if we can simplify things for you and start off rather basic.

Let's start with the three *primary colors* of red, yellow and blue. You cannot make any of the primary colors, nor can you make white. All other existing colors are made from the various hues of yellow, red and blue. Without these three colors, it is impossible to create variations of orange, green and violet commonly referred to as the *secondary colors*. The three primaries are also needed to make all the grayed or *tertiary colors*.

Experimenting with the mixing of the primary and secondary colors is essential to training your eye and being able to quickly mix any color required for your painting. When you start creating the color charts, you will quickly learn what it takes to make all the other colors.

Creating Secondary Colors

The primary colors are red, yellow and blue. When you combine any two primary colors you create a secondary color. Mixing yellow and red, produces orange, mixing yellow with blue creates green and combining a cool red with blue creates violet.

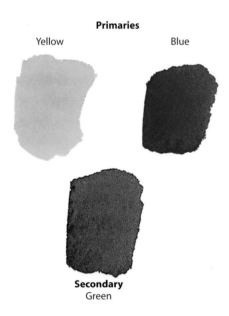

Primaries

Yellow Blue

Secondary
Green

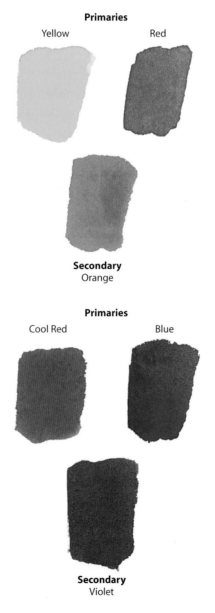

Primaries

Yellow Red

Secondary
Orange

Primaries

Cool Red Blue

Secondary
Violet

Glossary

Familiarize yourself with the following terms:

Complementary Colors—any pair of contrasting colors that, when mixed in the right proportions, create a neutral gray

Earth Colors—permanent, low-priced pigments found in most parts of the world

Hue—the name of a color

Intensity—the strength of a color, usually as compared with gray

Local Color—actual, true surface color of an object

Opacity—the quality of not allowing light to pass through an object or material. The opposite of transparency

Primary Colors—the three colors that cannot be created by mixing other colors; yellow, red and blue

Secondary Colors—any one of the three colors created by mixing two of the primary colors; green, orange and violet

Intermediary Colors—mixed colors that fall between a primary and secondary color on the color wheel

Tertiary Colors—grayed colors obtained by mixing the three primaries together or any two secondaries

Tint—a color lightened by adding water

Tone—most often refers to the value of a color

Shade—a color darkened by introducing a darker color from the same family, the complement or the color black

Value—the relationship of any color to the lightest color, or white, and the darkest color, or black

Wash—a transparent coat or layer of color used with water

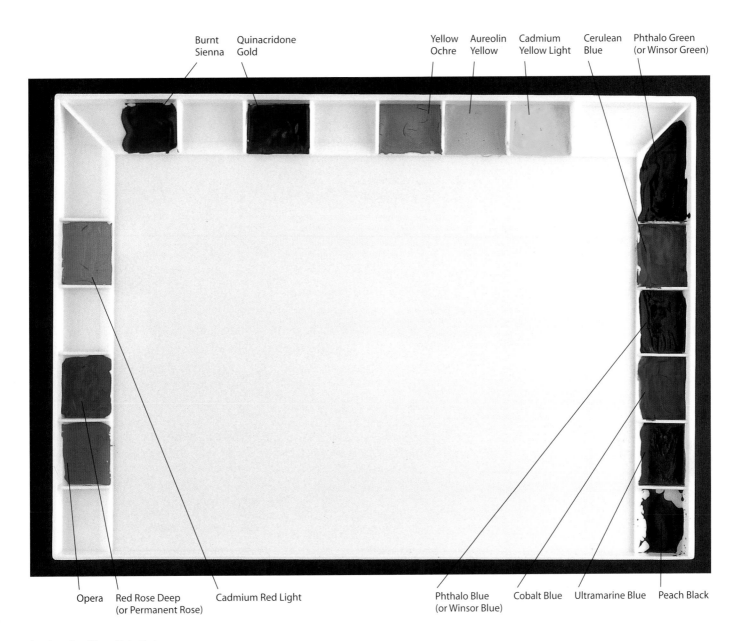

Burnt Sienna

Quinacridone Gold

Yellow Ochre

Aureolin Yellow

Cadmium Yellow Light

Cerulean Blue

Phthalo Green (or Winsor Green)

Opera

Red Rose Deep (or Permanent Rose)

Cadmium Red Light

Phthalo Blue (or Winsor Blue)

Cobalt Blue

Ultramarine Blue

Peach Black

Laying Out Your Palette

Find a palette that works for you. I like the John Pike palette. It has a large mixing area with plenty of wells. Don't be stingy with putting color in the wells of your palette. Keep the layout simple and consistent, placing the same colors in the same wells every time. Leave a few wells open in case you want to add colors. I place my colors on the palette by color families, from light to dark, which also reads warm to cool.

Limiting your palette

Out of all these, I generally paint with only three colors, and no more than five for each painting.

Alizarin Crimson ✳ Aureolin Yellow ✳ Brilliant Orange ✳ Burnt Sienna ✳ Cadmium Orange ✳ Cadmium Red Light ✳ Cadmium Yellow Light ✳ Cerulean Blue ✳ Cobalt Blue ✳ Lemon Yellow ✳ Manganese Blue ✳ Opera ✳ Peach Black ✳ Permanent Rose ✳ Phthalo Blue ✳ Phthalo Green ✳ Quinacridone Gold ✳ Raw Sienna ✳ Red Rose Deep ✳ Sap Green ✳ Ultramarine Blue ✳ Viridian ✳ Winsor Red ✳ Yellow Ochre

The color wheel

I often ask students who attend my workshop for the first time if they know the color wheel. A few say "yes." Then I ask, "Right side up, upside down and in your sleep?" The answer then becomes a resounding "no." Before painting with color, you should learn the color wheel. It's really very simple.

If you go to the art supply store and stand in front of the racks looking at the tubes of paint, you'll soon realize that there are many different hues of red, yellow, blue (the primary colors) and green, violet and orange (the secondary colors).

Tertiary Colors

In addition to the primary and secondary colors, there are the *tertiary* or earth colors: Burnt Sienna, Burnt Umber, Cobalt Violet, Indigo, Raw Sienna, Raw Umber, Quinacridone Gold, Payne's Gray and Yellow Ochre. That leaves only black and white. That's all there is, really!

Let's talk about the term *tertiary*. There seems to be conflicting ideas as to the meaning of tertiary. Webster's Dictionary defines tertiary as "thirds." I am a great admirer of artist Richard Schmid. This is what Richard says about tertiary in his book *Alla Prima: Everything I Know About Painting* (Stove Prairie Press: Longmont, CO, 1998). "The Tertiary Color Families—all three primary colors mixed together. All the grays, browns and earth colors." Ralph Fabri believes that "Any two secondary colors mixed together form a tertiary color. A tertiary color may be reddish brown, which would include the yellows or bluish brown, which would include the violets." For example, when you mix orange and green, you actually mix yellow and red with yellow and blue. That would be two parts yellow, one part red, and one part blue.

You will often see books refer to tertiaries as yellow-green, green-yellow, etc. Instead, I consider these to be intermediary colors, because they fall between a primary and secondary color on the color wheel. Tertiaries are the mixture of all three primaries or two secondaries creating the color gray and are located in the center of the color wheel.

The Color Wheel

This color wheel shows each primary, secondary and intermediary color and their tints produced by adding water. When mixing each color with some of its complement (the opposite color on the wheel), the color becomes grayer, eventually becoming tertiary as it reaches the center of the wheel.

The colors on the outside row are tints of the primaries, intermediary and secondary colors, which are located in the second row from the outside. The third, fourth and fifth rows show what happens to a color when it is gradually mixed with its complement. For example, orange plus a touch of blue grays the orange down. Adding more blue neutralizes the color further, and even more blue takes it to gray at the center of the wheel. Another example is blue plus a touch of orange, which grays the blue. More orange begins to neutralize the blue and even more orange takes the color to gray, located in the middle of the wheel. This shows how any color becomes grayer and grayer once it has all three primaries introduced into it. This is how the tertiaries are made. Yellow plus red equals orange. Adding blue to the mix gives you all three primaries, which produces a tertiary (grayed) color.

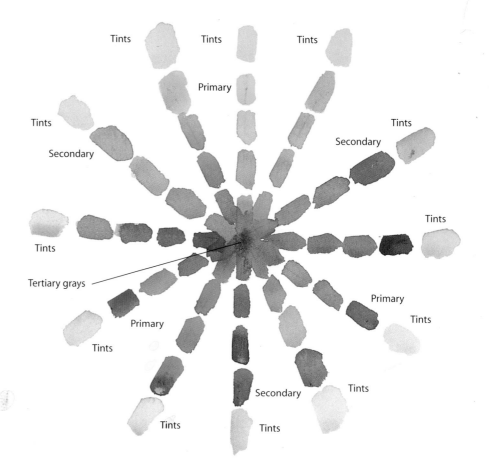

Tints — Tints — Tints — Primary — Tints — Secondary — Tints — Tints — Primary — Tints — Secondary — Tints — Tints — Secondary — Tints — Tints — Primary — Tints — Tertiary grays

Color triads

A *triad* is any equilateral grouping of three colors. When working with a primary triad, you can use different hues of red, blue and yellow to obtain endless possibilities of color combinations. For example, create a triad of Yellow Ochre, Cadmium Red Light and Ultramarine Blue. Yellow Ochre is a tertiary color created from yellow, red and blue. When mixed with Ultramarine Blue, it will create either a grayed yellow-green or a grayed blue-green. When mixed with Cadmium Red Light, Yellow Ochre will create a grayed yellow-orange or a grayed red-orange. Cadmium Red Light has yellow in it, therefore when mixed with Ultramarine Blue, it creates a brownish gray or a bluish gray depending on which color is dominant. You won't be able to mix any clean violets with this particular palette. Always remember if you want clean secondary violets or purples, choose a cool red such as Permanent Rose, Red Rose Deep or Opera to mix with any blue for satisfying results.

Triads

You can create a triad on the color wheel by drawing an equilateral triangle between any three colors. Aureolin Yellow, Winsor Red and Cobalt Blue form the primary triad shown as the equilateral triangle with the point at the top. Orange, green and violet form a secondary triad shown as an equilateral triangle pointed down. You can rotate the triangle around the wheel and find two more triads: yellow-orange, blue-green and red-violet, and red-orange, yellow-green and blue-violet.

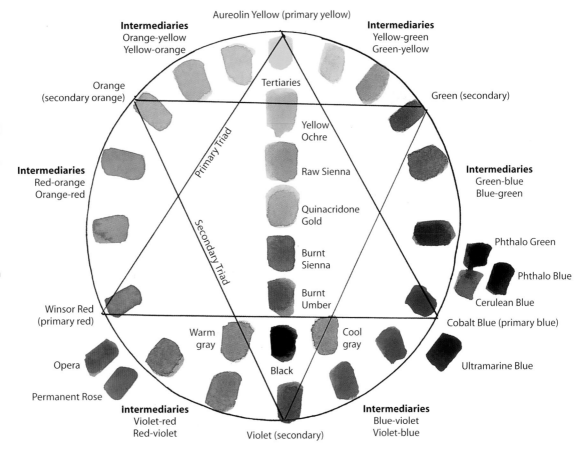

Exercise: A Bracelet of Color

Try this exercise using a limited palette of Aureolin Yellow, Opera, Cobalt Blue and Phthalo Blue (left column). Starting with yellow, mix all of the colors that make up the color wheel. Two different blues are used because Phthalo Blue will mix vibrant green-blues and blue-greens. A cool red like Opera is used to mix clean violets. Then try some grays (right column) in different temperatures by mixing the three primaries.

Because you will be using a limited palette, this exercise reinforces the color wheel visually and teaches you how to quickly mix colors for the wheel in the correct order, painting the colors with a juicy, confident application.

Complementary colors

Colors that are opposite one another on the color wheel are called *complementary colors*. When placed next to one another in a painting, they create tension and interest. Their energy and vibrance attracts the eye.

The most common pairs of complements are yellow and violet, blue and orange, and red and green. Some less obvious complements are yellow-green and red-violet, blue-green and red-orange, and blue-violet and yellow-orange. Use your color wheel to locate complementary colors to use in your paintings.

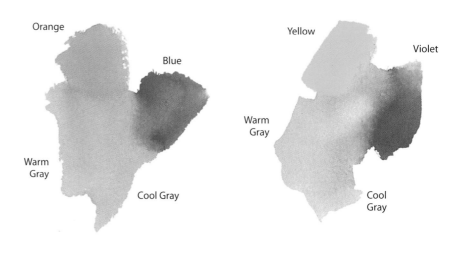

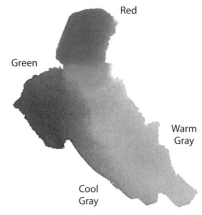

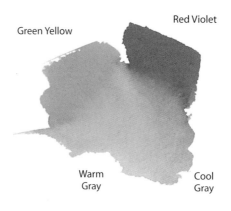

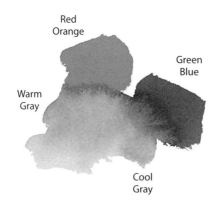

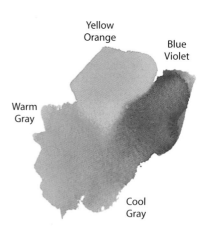

Matching Up Your Complements

Any two colors that appear directly opposite each other on the color wheel are complements. When placed side by side they look great or they "compliment" one another. Mixed together they cancel each other out and produce the tertiary color gray.

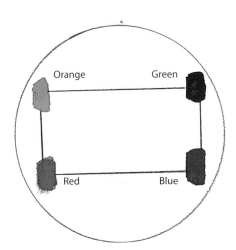

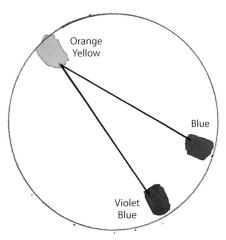

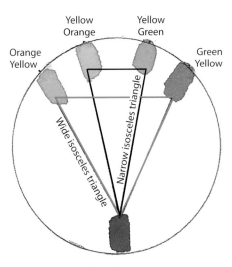

Double Complements

A double complement is any four colors that form a rectangle on the color wheel. Orange, red, green and blue is a good example of a double complement. Some other double complements are: yellow-orange, blue-violet, yellow-green, red-violet; or blue-green, red-orange, blue-violet, yellow-orange; or yellow, violet, green and red.

Each one of these double complements can be a color palette for a painting. You need to know which tube color matches the complement color. For example, red-violet could be Permanent Rose, blue-green could be Viridian or Phthalo Green, and red-orange could be Cadmium Red Light or Vermilion.

Isosceles Triangle Palettes

This isosceles triangle shows a color palette of blue, violet-blue and orange-yellow. An isosceles triangle has two equal sides and one unequal side. Isosceles triangles can be placed on the color wheel to create many color combinations that you can use for devising palettes for your paintings. Try orange, red-orange and blue.

Two Isosceles Triangles

This diagram has two isosceles triangles, one narrow, one wide. By varying the size of the triangle, you can create different types of palettes. The wider, outer triangle is composed of orange-yellow, green-yellow and violet. The smaller, inner triangle is made up of yellow-orange, yellow-green and violet.

Analogous colors

A good way to darken a color and keep it in the same family is to work analogously. *Analogous colors* are found next to one another on the color wheel. For example, start your palette with Aureolin Yellow, then add Aureolin Yellow plus Yellow Ochre, followed by pure Yellow Ochre, then Yellow Ochre plus Quinacridone Gold, then Quinacridone Gold plus Burnt Sienna, then Burnt Sienna. You'll be surprised what you'll learn about color when you do these color charts and become more confident in your color choices.

The knowledge and use of analogous color expands the painter's ability to spark color by introducing a color above or below it on the color wheel, thereby exciting the color, keeping it much cleaner and usually brighter.

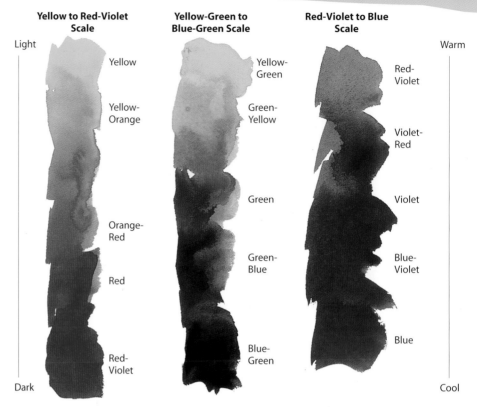

Yellow to Red-Violet Scale
Light

Yellow
Yellow-Orange
Orange-Red
Red
Red-Violet

Dark

Yellow-Green to Blue-Green Scale

Yellow-Green
Green-Yellow
Green
Green-Blue
Blue-Green

Red-Violet to Blue Scale
Warm

Red-Violet
Violet-Red
Violet
Blue-Violet
Blue

Cool

Analogous Color Scales
Analogous colors are four or five colors that are close to each other on the color wheel. Try painting your own analogous scales of color.

Apple and Pear

Try painting simple objects using a limited analogous palette, such as this apple (warm) and pear (cool) using a palette of Aureolin Yellow, Opera, and Phthalo Blue, which is the same palette used in *So Curious* (page 77).

The apple is painted starting with an orange-red in the light area, moving to red and then to red-violet on the shadow side. The shadow is painted with blue, then as it moves away from the apple, violet and then red. The shadow directly under the apple is painted with a mixture of blue, red and orange. Always paint with a variation of color, temperature and value. The highlight is white paper.

The green pear goes from orange to yellow, to yellow-green, to green, to green-blue. The shadow is a gray mixture made from green-blue and orange accented with orange. The pear appears to be warmer than the apple because it has more yellow in it. Painting simple subjects will help you learn to use color. It's not so overwhelming and is a good place to start.

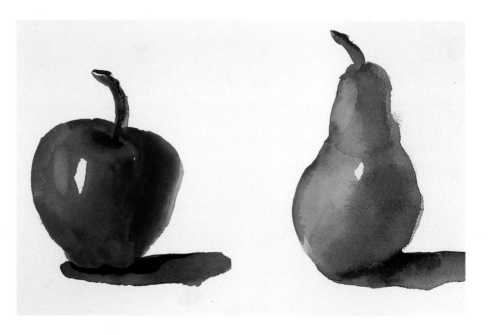

Examples of analogous color usage

Using analogous colors in your paintings has many benefits. They provide a sense of unity and harmony to your work. They also automatically limit your color palette, which will help you determine color temperature. It is also easy to establish a mood or feeling for your painting when using colors that are related to one another.

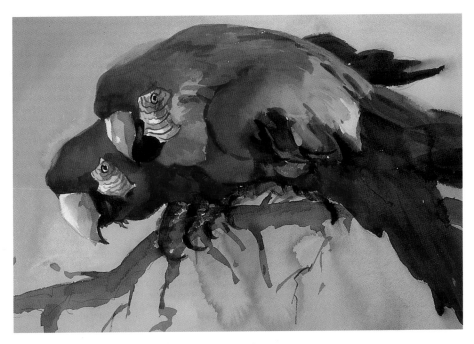

An Analogous Palette of Red and Blue
The parrots are painted with a palette of Aureolin Yellow, Opera and Phthalo Blue. This is the same palette used to paint the apple and pear on page 76. The more intense reds were mixed with Aureolin Yellow and Opera. The darker reds were the same mix with blue added, and then more red and a touch of yellow. Greens were made with Aureolin Yellow and Phthalo Blue. Blue-violets were made with Phthalo Blue and Opera. The painting is warm overall with a cool accent.

So Curious • 15" x 22" (38cm x 56cm) • *Collection of Christine Lesak*

A Red and Yellow Analogous Palette
Raggedy Ann's hair has been painted analogously with yellow-orange, orange, orange-red, red-orange, red and red-violet. The analogous color scheme is very effective; it works to capture the light in the doll's hair.

Raggedy Ann • 11" x 15" (28cm x 38cm) • *Collection of the artist*

"Your work is only as good as your weakest painting." —Claude Croney

Creating a color chart

Why should you spend time making color charts and value scales in color? Isn't that just a waste of time? Absolutely not. There are many subtle changes in colors, and creating color charts will teach you that each color can be easily altered or changed by the addition of another color or colors. Mastering the art of mixing color will help you match any color required for painting. Economy of paint means fewer tubes of paint, but you'll get just as much mileage out of fewer tubes because of your ability to see and mix whatever you need.

The top row on the left is the palette of Aureolin Yellow, Permanent Rose and Cobalt Blue. When working up a color chart, I always put the palette on the top row and the name of the color in pencil. How does this chart work? The first color, Aureolin Yellow, is mixed with the second color, Permanent Rose, to makes a secondary orange. Now we are painting a value scale making the orange darker each time, taking it from light to dark as well as from warm to cool.

Here is the secret to keeping the color in the same family as it becomes darker and cooler: When the color swatch becomes a number five value, add a little blue to the mixture, then add a touch of red and a touch of yellow back into the puddle of color. This pushes the color back to the orange family. Repeat this process for the value scale of orange until it is as dark as you can get it without spoiling the integrity of the color. This process causes the orange to become grayer as it gets darker. All shadows have a little blue in them, so these colors will become grayer whenever you put all three primaries together. We'll cover shadows a little further along on page 84.

Start the process again for the next row, which is green. Mix Aureolin Yellow with Cobalt Blue until it reaches a number five value for the first swatch. Add a little red to darken the color, followed by blue and yellow to push it back to the original color family. Get the idea?

The exception to this process is the violets. When making violets you will only work with red and blue—don't introduce yellow into these colors—so that the violets stay cleaner. For example, combine Permanent Rose with Cobalt Blue and add a little more Permanent Rose. This will keep the color secondary and in the red-violet family. Another example is Cobalt Blue plus Permanent Rose plus more Cobalt Blue. This will keep the color secondary and in the blue-violet family.

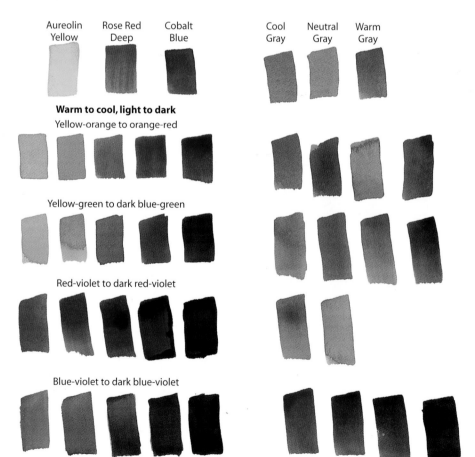

Warm to cool, light to dark
Yellow-orange to orange-red

Yellow-green to dark blue-green

Red-violet to dark red-violet

Blue-violet to dark blue-violet

Create a Color Chart
The right side of this color chart is a mixture of yellow, red and blue to produce different combinations of gray. The individual colors are introduced into this gray to produce many various beautiful warm or cool grays, which I use all the time in my work. The brighter, cleaner colors are usually saved for my center of interest and the biggest portion of the painting will be grayed colors.

The grayed colors are created by mixing blue, red and yellow to create a brown. More blue is added to create the neutral gray. Adding a small amount of blue to the neutral gray creates the cool gray. Add a little red and yellow to the neutral gray to make the warm gray. Mixing each color from your palette to the neutral gray will produce a variety of grays.

Selecting a limited color palette

I use the palette of Aureolin Yellow, Permanent Rose and Cobalt Blue for almost everything including portraiture. It's a very versatile palette and is the one that I recommend for beginning artists. This palette can be seen in *Female Study*.

Keep in mind that these are the three primary colors—yellow, red and blue—and that green, violet and orange are made from mixing the primaries. If you mix all three primaries together, you'll produce some form of gray—a cool one, a warm one or a neutral one. If you mix any two secondaries together, you're going to come up with another form of gray. Theoretically if you have a warm and a cool of each primary color, you should be able to mix any color you could possibly want or need.

My Favorite Limited Color Palettes

Three primary colors straight from the paint tubes are generally all that I need for a painting, but occasionally I include five or six tube colors. Here are some of my favorite color combinations.

✱ Aureolin Yellow, Permanent Rose and Cobalt Blue

✱ Aureolin Yellow, Opera and Phthalo Blue

✱ Quinacridone Gold, Red Rose Deep and Ultramarine Blue

✱ Aureolin Yellow, Permanent Rose, Phthalo Green and Phthalo Blue

✱ Aureolin Yellow, Cadmium Red Light and Ultramarine Blue

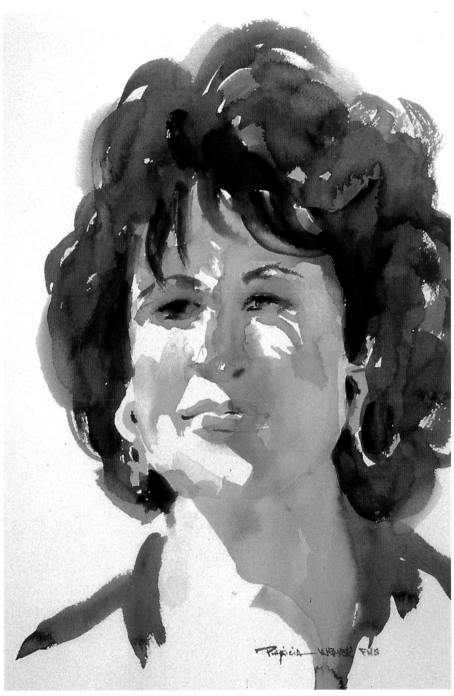

Painting With a Limited Palette

A limited palette of Aureolin Yellow, Permanent Rose and Cobalt Blue was used for this painting. The values in the skin tones are very light so they require a good bit of water mixed with the paint. Permanent Rose was floated in first, followed by Aureolin Yellow, then a touch of Cobalt Blue for cool relief. The fluid colors were mixed on dry paper. I used less water for the values in the hair. First I floated in Cobalt Blue; then while still wet, I introduced Permanent Rose, followed by some Aureolin Yellow, which creates a brownish tertiary color.

Female Study • *22" x 15" (56cm x 38cm) • Collection of the artist*

Examples of limited color palette

Using a limited color palette sounds like it doesn't give you a lot of options, but it does. Look at the variations that can be achieved by using these limited palettes. There are many great things to be said about using limited palettes. They create unification in your painting and present fewer decisions when making color selections. And no matter how you mix the colors in a limited palette, they work well together because they are related to each other. The grays that are made from a limited palette use all the colors of the selected palette and they work well with any individual color or with other color mixtures from the same limited palette.

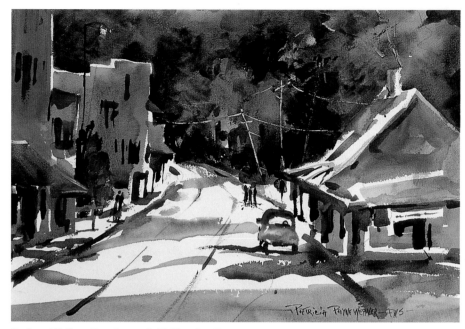

Red and Yellow Dominate, Add Blue for Grays
I painted this using a palette of Aureolin Yellow, Cadmium Red Light and Ultramarine Blue. When the warm red and cool blue are mixed together, they make grayed reds, browns and blue-grays. The foliage is painted with a combination of yellow, blue and a touch of red for grayed yellows and greens. The warm shadows are a mixture of Cadmium Red Light and Ultramarine Blue.

Black Mountain • *22" x 30" (56cm x 76cm)* • *Collection of the artist*

The Same Gray Palette
See how the colors in *Jackson Square Tappers* relate to the colors in *Black Mountain*. This is the same palette using different proportions of each color and a totally different subject matter.

Jackson Square Tappers • *15" x 22" (38cm x 56cm)* • *Collection of the artist*

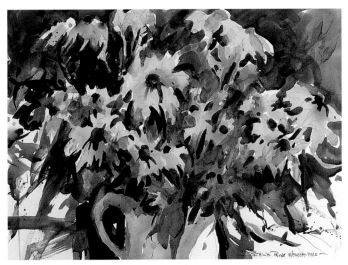

Same Palette, Different Temperature Dominance

Black-Eyed Susans and *Hayfields of Provence* are examples of how the same palette can work for two paintings even though the subject matters are entirely different. Study both paintings and you'll see the exact same color mixes and values. The biggest difference in the two paintings is the amount of white paper saved.

Yellow is the dominant color of *Black-Eyed Susans*, with a limited palette of Quinacridone Gold, Red Rose Deep, which appears cool next to Quinacridone Gold, and Ultramarine Blue. Quinacridone Gold is a tertiary color and when mixed with each of the other two colors produces calming grays.

Black-Eyed Susans • *15" x 22" (38cm x 56cm)* • *Collection of the artist*

More Cool Than Warm

The same palette as *Black-Eyed Susans* is used to paint *Hayfields of Provence*, but now the color notes are played for a landscape. Notice how the gray-violet sky complements the yellow hayfield. The variations you can achieve with just three colors are endless.

Hayfields of Provence • *15" x 22" (38cm x 56cm)* • *Collection of the artist*

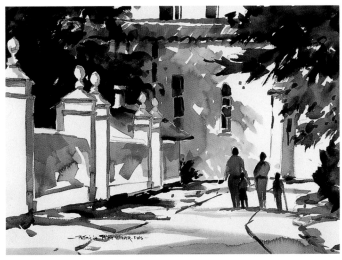

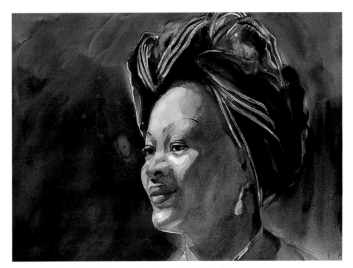

Rich Dark Greens

Soreze is in the south of France below Toulouse. Napoleon Bonaparte went to school here. I used a palette of Aureolin Yellow, Permanent Rose, Phthalo Green and Phthalo Blue. The largest piece (*Papa*) in this painting is the white paper. Phthalo Blue or Phthalo Green mixed with Quinacridone Gold makes a beautiful grayed green.

Soreze, France • *15" x 22" (38cm x 56cm)* • *Collection of Barbara McKenzie*

Contrasting Rich Warms Against Cool Darks

I used the same palette of Aureolin Yellow, Permanent Rose, Phthalo Green and Phthalo Blue that I used in *Soreze, France*. These are two totally different subjects, but this palette works well for each painting. The colors used produce rich skin tones and a dark rich gray color for the background.

Zimbabwe Woman • *15" x 22" (38cm x 56cm)* • *Collection of the artist*

Mixing blacks using a limited palette

When mixing blacks, always start with the darkest color, add the middle value to it and finally add a touch of the lightest color. A small amount of water will give you a very dark value, more water will push your pigment to a middle value and a lot of water will produce a light value.

It's just not possible to tell you exactly how much water to add to a certain amount of paint. This is something you have to practice for yourself. Learn to see and feel the paint mixtures. Dark color can be painted into very wet middle value color without blooms occurring if you understand how much, or how little,

water to mix with the paint. I use a small amount of water in my darks and go directly into wet paint on the paper so the darks don't move. Try it. It really works!

Combining Colors to Make Black

Some good color combinations that produce black are: Ultramarine Blue, Cadmium Red Light and Aureolin Yellow; Red Rose Deep (or Permanent Rose) and Phthalo Green; Ultramarine Blue and Burnt Sienna; Cadmium Red Light and Ultramarine Blue; Phthalo Blue, Cadmium Red Light and Quinacridone Gold. Use these combinations or create your own to make beautiful, colorful blacks.

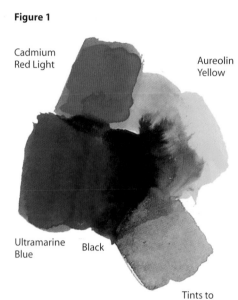

Figure 1

Cadmium Red Light

Aureolin Yellow

Ultramarine Blue

Black

Tints to Gray

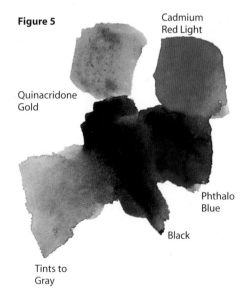

Figure 2

Phthalo Green

Red Rose Deep

Makes Black

Tints to Gray

Figure 3

Burnt Sienna

Ultramarine Blue

Black

Tints to Gray

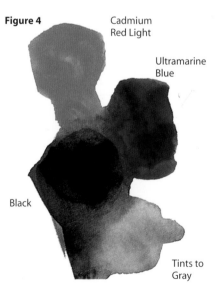

Figure 4

Cadmium Red Light

Ultramarine Blue

Black

Tints to Gray

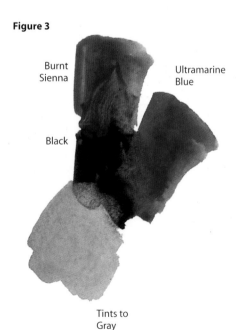

Figure 5

Cadmium Red Light

Quinacridone Gold

Phthalo Blue

Black

Tints to Gray

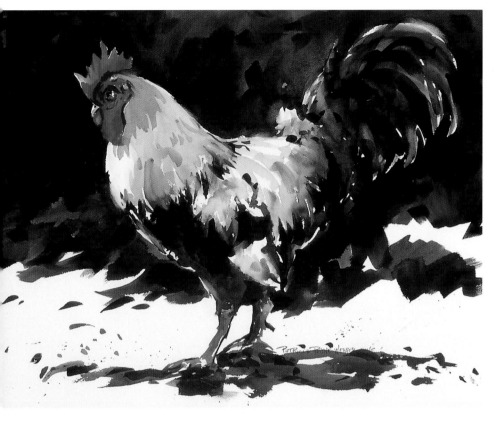

Painting With Black

So Sure of Himself was painted with a triad of Ultramarine Blue, Cadmium Red Light and Aureolin Yellow as shown in color swatch 1. I wanted to keep my colors limited and make the rooster really pop against the background. I believe you should paint the same colors into the background that are in the subject. The value of the background had to be very dark, but not solid. I wanted the viewer to see color in what appears to be black.

Some of the warm colors from the rooster's comb and neck feathers were introduced into the background for some warm relief. Notice that I have practiced the theory of placing something light next to something dark. The shadows under the rooster are the same colors and dark enough in value that they anchor the rooster to the ground. Also, note the lost or soft edges.

So Sure of Himself • *22" x 22" (56cm x 56cm)* •
Collection of Barbara Aras

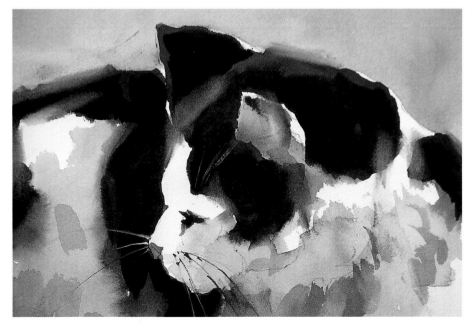

Painting in Black and White

Color swatch 4 was the palette used to paint this little kitty. This is a limited palette of Cadmium Red Light and Ultramarine Blue. A two-color palette is about as limited as you can get without painting monochromatically.

It's a simple painting, but strong in value contrast and very effective. The cat's face is the focal point and is very light against very dark. The beautiful blues are a result of lifting color and softening edges while the paint was still damp. The nice grays are produced from blue with a little red and more water. Note that the largest white piece, which is just white paper, is reserved for the face of the cat.

Patiently Waiting • *11" x 15" (28cm x 38cm)* •
Collection of Christine Hagin

Creating shadows

When it comes to shadows, a lot depends on the intensity of the light. If it is a bright sunny day, the shadows will be stronger. If it is an overcast day, there may be very little shadow. Squint to read the values. When painting from life, use only one light source. This applies to still-life and figure painting. One light source placed in the right position can create wonderful, dramatic shadows.

Cool light produces warm shadows, warm light produces cool shadows and all shadows have a little blue in them. You want to maintain this contrast to create interest in your paintings. When painting a shadow on a white surface, I try to make it more than just a gray shadow. I introduce colors from the objects that are casting the shadow. Remember, horizontal planes receive more light; vertical planes receive less light.

Edges are an important consideration. Create some lost edges as the shadow becomes lighter in value. Losing edges keeps your subject from looking like it has been cut out and pasted to the paper.

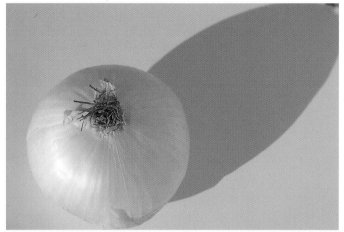

Bounced Color
The shaded side of the onion and the onion's cast shadow have been greatly enhanced by the introduction of bounced color from the background. Make your subject more than it is by including reflected color. This creates interest and unity in your painting.

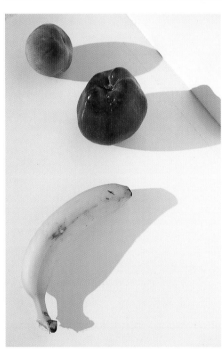

No Added Color
Boring, boring, boring. These shadows have no life and are very uninteresting. The fruit and the table appear disconnected and isolated from one another. This would make a very uninteresting painting.

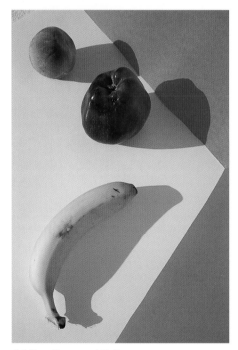

Adding Bounced Color
Wow! What a difference bounced color can make. I introduced some hot pink and red posterboard to demonstrate how to make your shadows and the objects you're painting much more exciting by introducing additional color. Notice how much darker the shadows are on the vertical plane. The composition is interesting and unified by simply adding color.

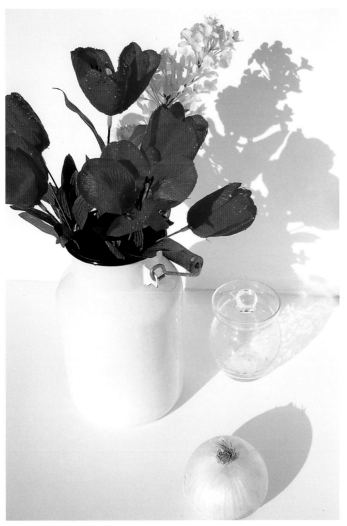

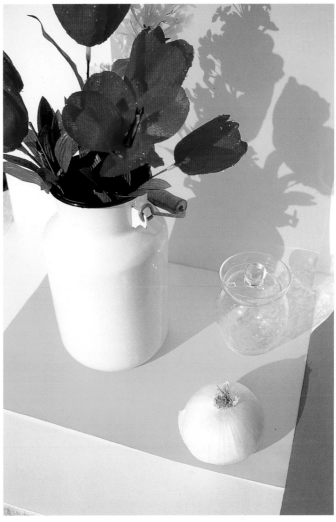

A Colorless Still Life

Again, this subject is okay, but if you want to paint white on white, take a look at the next example where color has been introduced.

Adding Color to Your Setup

Now, we see how color can be introduced into the white surface of the container, the onion and the glass container. The surface that everything sits on could still be white, but introduce color into the shadows instead of just painting gray, flat shadows. The colored paper is for illustrative purposes only.

Using colors in cast shadows

Shadows created by a direct light source that fall on other planes are *cast shadows*. For example, when you are standing outside in bright sunlight, the shadow you see on the ground is your cast shadow.

If a shadow is cast over a colored surface, most often it will be three to four values darker and in the same color family as the surface. If the surface reads as a number 2 or 3 value, then the shadow could read as a 5 or 7. If a tablecloth is painted in hues of yellow, the shadow will be yellow, but three to four values darker. In addition, I usually introduce colors from the object casting the shadow, but not so much that it doesn't read as yellow anymore.

Local Color **Shadow Color**

Yellow

Red

Blue

Red-violet

Green

Blue-violet

Local Color **Shadow Color**

Orange

Red-orange

Green-blue

Red

Blue-green

Gray

What Is the Color of the Shadow?
Each local color swatch has the shadow color to the right of it. Shadows are generally three to four values darker than the local color.

Limited Palette
Jack Russell Terrier is another example of a limited palette with an overall warm temperature—Aureolin Yellow, Quinacridone Gold, Permanent Rose and Ultramarine Blue. The cast shadow is a darker brown than the dog and a darker value than the ground. I usually paint my backgrounds with the same colors as the subject, either lighter or darker in value and in the same color temperature. To stay focused on the animal, I keep my backgrounds and cast shadows simple.

Jack Russell Terrier • *30" x 22" (76cm x 56cm)* • *Private collection*

Using a grayed palette

The word mud is often heard in watercolor painting. I truly never see mud on the palette, just beautiful gray color. I think mud happens by making the wrong color choices or by overworking the paint on the paper. Watercolor is a little temperamental and really doesn't appreciate being stirred on the paper.

You want to fully charge the brush with fluid paint and float the paint onto the paper using a light touch. If you press down too hard or too long when applying the paint, the brush will act as a sponge, sucking the color right back off the paper, resulting in a very dry, dull look.

Overworking the painting—taking paint off, putting paint on, dab, dab, dabbing with a facial tissue or paper towel—destroys the color on the paper. If you have vanilla ice cream and chocolate ice cream side by side, they are still identifiable; but continuously stirring them will soon destroy their individual identities. It is the same with paint, don't stir too long on the palette or the colors will be lost. Do some mixing on the palette, but most of the color mixing occur naturally on the watercolor paper.

Exercise

Here is a fun exercise for learning to match color. Use art magazines as references to select paintings that are similar in color. Organize them into groupings of two to five paintings. Then select a limited palette and see if you can mix the colors that are in the paintings. Be sure to include the dark values. Remember the white paper will represent the lightest value. The object is to avoid introducing a tube color into the palette that is not in the grouping of paintings.

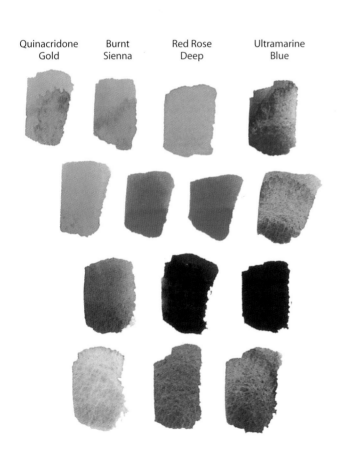

Quinacridone Gold — Burnt Sienna — Red Rose Deep — Ultramarine Blue

Graying Your Palette
Quinacridone Gold, Burnt Sienna, Red Rose Deep and Ultramarine Blue are the primary colors used for this tertiary palette. These earth colors combine beautifully to form the basic palette for *Mouser*. (See page 113 for a complete demonstration of *Mouser*.)

No Mud, Just Gray
Mouser is a good example of the use of a grayed palette with blue, red and yellow used for the darks in the cat's fur. No muddy color here, just rich gray color.

Mouser • 30" x 22" (76cm x 56cm) • Collection of Dr. Donna Cohen, USF

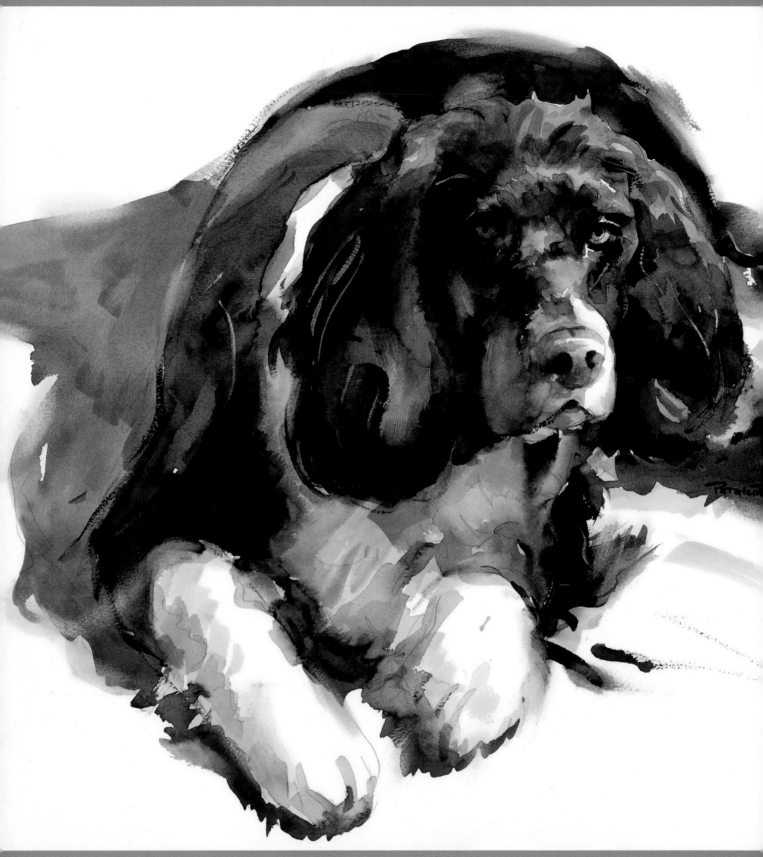

Devotion • 18" x 24" (46cm x 61cm) • *Collection of the artist*

demonstrations

Nine direct painting demonstrations show you how to tie all the concepts in this book together. Various subject matter—architecture, florals and animals—are broken down into easy-to-understand steps using limited palettes.

Painting directly on watercolor paper allows you to begin without stretching or wetting the paper ahead of time. The paper is simply clipped to a piece of gator board and the process begins. Consideration is always given first to the subject, then how to handle it through composition and design.

In most of the demonstrations there is a simple line drawing, a black-and-white value painting or pencil study, and a color palette, all determined before the actual painting begins. These are all fun paintings to do; some more challenging than others, demonstrating how to paint a variety of subject matter. The only way to learn is by doing, so now is a good time to start. Remember, time invested in practice is time well spent.

Painting with Analogous Colors

materials

Pigments · Aureolin Yellow · Opera · Cobalt Blue

Brushes · 1-inch (25mm) angular flat · No. 2 script liner · No. 8 round

Paper · 140-lb. (300gsm) cold-pressed Arches, 8" x 17" (20cm x 43cm)

Color Palette

First row: Aureolin Yellow, Opera and Cobalt Blue.

Second row: Yellow-orange, orange-yellow, orange and red-orange.

Third row: Mixture of dark orange (Burnt Sienna) made from the red, yellow and blue and a darker orange made by adding a little more blue.

Fourth and fifth rows: Dark orange made by adding more blue (Burnt Umber) and then another swatch for an even richer and darker color.

Painting directly without drawing is my favorite way to work, because of the freedom in it. The colors stay fresh and the work looks spontaneous. Jump in there and try it. You have nothing to lose and everything to gain.

The painting is begun on dry paper. After the first color is applied to the paper, you will be painting wet-into-wet. This is a great exercise for teaching you to see shapes. As Ed Whitney constantly reminded us, artists are shapemakers.

Reference Photograph

When painting directly from a photograph without drawing, I hold the photograph in my left hand. I concentrate and am keenly aware of my subject. Think of your eyes as a scanner, transmitting the information to your brain, which directs it to your hand that controls the brush.

1 Paint the Primary Shapes

Begin this painting on dry paper using yellow, orange, red-orange, red and red-violet. Pay very close attention to the shapes, as there are no pencil lines to guide you. Begin painting the shapes with a 1-inch (25mm) angular flat applying yellow-orange, adding orange and then red-orange. Using a no. 8 round, float a touch of blue into the stem for some cool relief.

2 Add the Second and Third Flowers

Continue the painting process with the 1-inch (25mm) angular flat, making sure that you change colors and values as you go. Carefully observe the shapes and design. This is a good time to remind you that analogous colors lay close to each other on the color wheel.

3 Final Step

Continue using the analogous colors to paint to the bottom of the paper, maintaining good shapes and occasionally introducing blue for some cool relief. Add a little calligraphic detail using a no. 2 script liner.

My Calla Lilies • *15" x 11" (38cm x 28cm)* • *Collection of the artist*

"I just put in enough detail to try to complete the painting, because I'm not interested in detail." —Claude Croney

Painting Strong Contrasts

materials

Pigments · Aureolin Yellow · Opera · Cobalt Blue

Brushes · 1-inch (25mm) angular flat · 2-inch (51mm) synthetic flat · No. 2 script liner · Nos. 8 and 20 rounds

Paper · 140-lb. (300gsm) cold-pressed Arches, 8" x 17" (20cm x 43cm)

This French cloister is near Apt, France, and was sitting all alone in a very large field on a hill. The way the light was hitting it created strong contrast between the sunlit areas and areas in shadow. This is a compelling subject that I've tried to handle in a simple manner using the same palette as in *My Calla Lilies* (pages 90–91).

Reference Photograph
This photograph was cropped to present a more interesting format and composition. Note the linkage of the darks and the linkage of the lights.

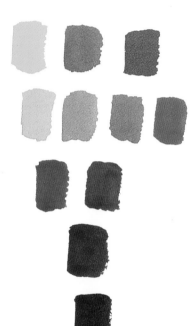

Color Palette
First row: Aureolin Yellow, Opera and Cobalt Blue.
Second row: Yellow-orange, orange-yellow, orange and red-orange.
Third row: Mixture of dark orange (Burnt Sienna) made from the red, yellow and blue and a darker orange made by adding a little more blue.
Fourth and fifth rows: Dark orange made by adding more blue (Burnt Umber) and then another swatch for an even richer and darker color.

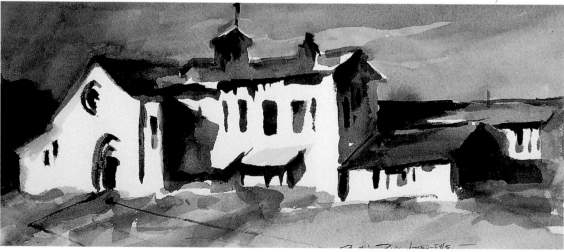

Value Study
This black-and-white value study was painted from the cropped reference photograph using Peach Black. The large linking white shapes create unity and contrast with the darker values of the roofs and background.

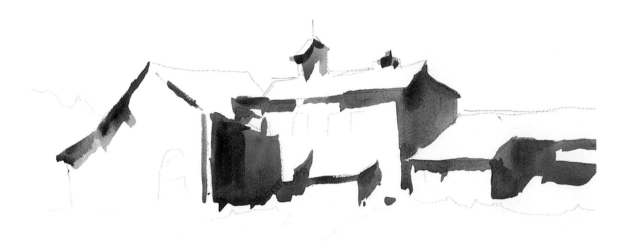

1 Paint the Shadow Shapes

Make a simple line drawing on 140-lb. (300gsm) cold-pressed Arches watercolor paper using the same horizontal format as in the value painting. Use the scaling-up technique to determine the size of your painting.

Paint the shadow shapes, linking all the middle, low-middle and dark values. Using fresh pigment to create a juicy paint mixture is an absolute must. Start with blue using a 1-inch (25mm) angular flat. While that is wet, introduce some red-violet and then a touch of yellow into all the linking shadow shapes.

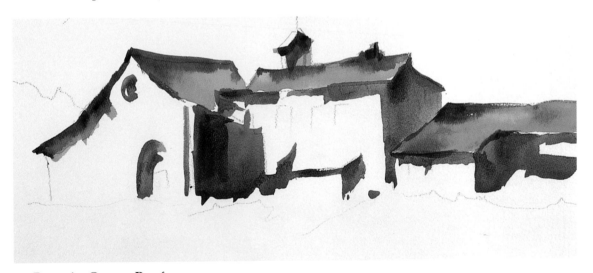

2 Paint the Orange Roofs

Paint the roofs of the buildings with the no. 8 round by mixing yellow and red to create orange. Add more red to that mixture for variations in the roofs. Occasionally float blue into the red-orange to darken the color and provide some cool relief to all the warm color. Remember when you add blue to the orange, also add a touch of red and a little yellow back to the mixture to keep it in the orange color family. Add a variation of orange in the doorway.

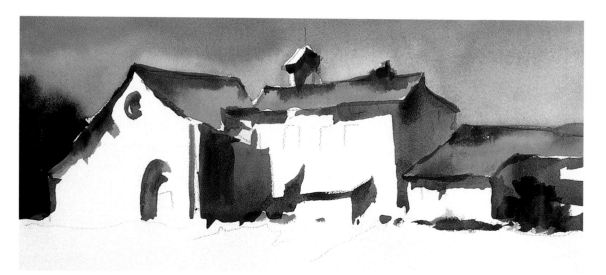

3 Paint the Sky and the Trees

Dampen the sky area with clean water using a 2-inch (51mm) synthetic flat. While wet, use a no. 20 round to paint the sky blue. Add blue mixed with red-violet to the sky. Float a little pale green mixture (yellow plus blue) into the sky (use more water to dilute the mixture for the lighter values) next to the roofs of the buildings. Remember that when there is something light, there should be something darker next to it. Paint the trees with a mixture of blue plus yellow with a touch of red to create a dark value.

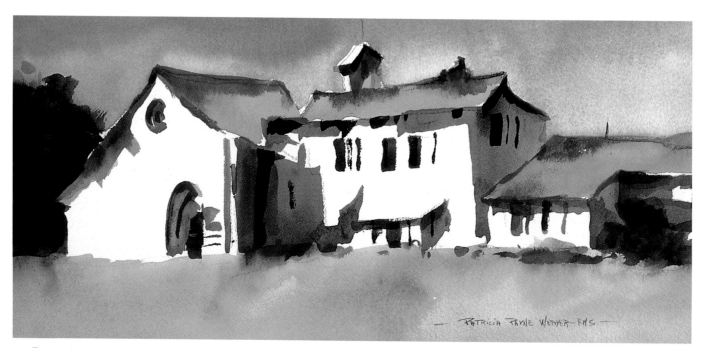

4 Paint the Foreground

Paint the foreground with a no. 20 round using a mixture of yellow plus blue, and a touch of red-violet to gray the yellow-green mixture. While wet, introduce blue directly into the yellow-green for cool relief. Add detail by introducing windows with a no. 8 round and a no. 2 script liner for a little calligraphy here and there. Make sure you have a variety of shape, color and value in the windows and the door.

French Cloister • *8" x 17" (20cm x 43cm)* • *Collection of the artist*

Painting Shapes Without Drawing

materials

Pigment · Aureolin Yellow · Quinacridone Gold · Red Rose Deep · Phthalo Blue · Phthalo Green

Brushes · 1-inch (25mm) angular flat · No. 2 script liner · Nos. 8 and 20 rounds

Paper · 140-lb. (300gsm) cold-pressed Arches, 8" x 17" (20cm x 43cm)

The staff at the wonderful bastide where I teach in Provence, France keeps fresh floral arrangements throughout the house, which provides a multitude of painting material for the students and myself. This arrangement has great shapes thanks to the large sunflowers and container. Painting without a drawing on the paper is not as difficult as you might think. Jump in there and try it.

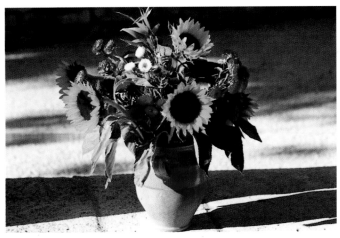

Reference Photograph
This photo was used for a drawing exercise on page 38. This demonstration will be a direct painting without drawing.

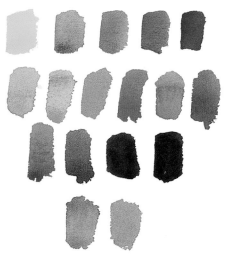

Color Palette
First row: Aureolin Yellow, Quinacridone Gold, Red Rose Deep, Phthalo Green and Phthalo Blue.
Second row: Aureolin Yellow is individually mixed with each additional color. Aureolin Yellow plus a little Quinacridone Gold; Aureolin Yellow plus a little Red Rose Deep for a yellow-orange; yellow-orange plus a little more Red Rose Deep creates orange; orange plus a little more Red Rose Deep produces orange-red; Aureolin Yellow plus a little Phthalo Green; this green mixture with a little Phthalo Blue producing a middle value green.
Third row: Quinacridone Gold plus Red Rose Deep; Quinacridone Gold plus Phthalo Green; Quinacridone Gold plus Phthalo Blue; and Quinacridone Gold plus Phthalo Blue with a touch of Red Rose Deep.
Fourth row: The gray mixtures are made from blue, red and a touch of yellow.

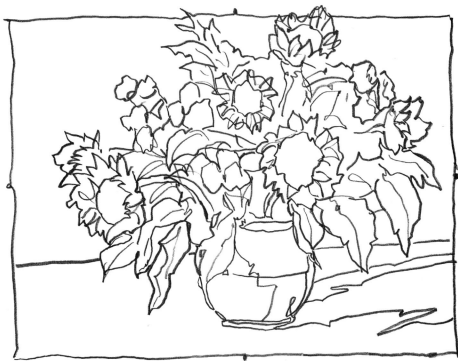

Line Drawing
This simple line drawing was used as a reference for *Sunflowers of Provence*.

1 Paint the Yellow Flowers

Hold the photo in your nondominant hand and be very observant. Paint the shapes of the sunflowers with a 1-inch (25mm) angular flat using yellow, red and a touch of blue to create a variety of yellows. Be careful when introducing blue into yellow and red as it can quickly turn green—use just a little bit of blue. Always start with a shape you understand and the big sunflower shapes are the easiest. Painting this way is like putting pieces of a puzzle together—very challenging and stimulating.

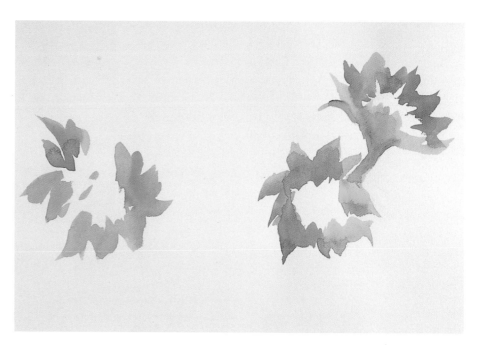

2 Focus on the Inside Shapes

Introduce some of the inside shapes, a few smaller red flowers and some leaf shapes. Gray down the reds of the flowers, as well as the greens in the leaves. Don't paint with pure color directly from the tube especially when it comes to the color green.

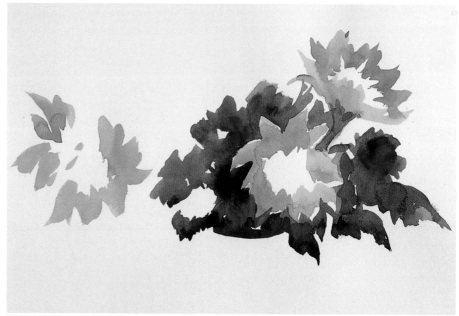

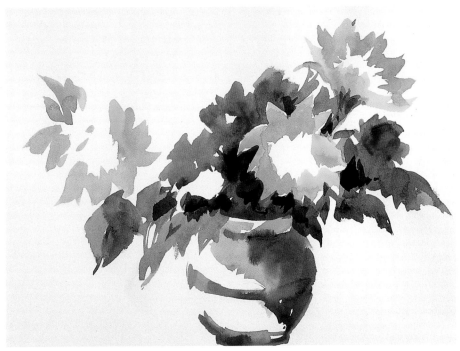

3 Add More Darks
Add a few more leaves, some dark shapes and define a white flower shape. Use a no. 20 round to paint the right side of the pot with variations of color, leaving a hard edge. Again, paint the shadows, not the light. The left side of the pot is only suggested with a soft edge into the white background. Use the same colors in the pot that are found in the flowers and leaves.

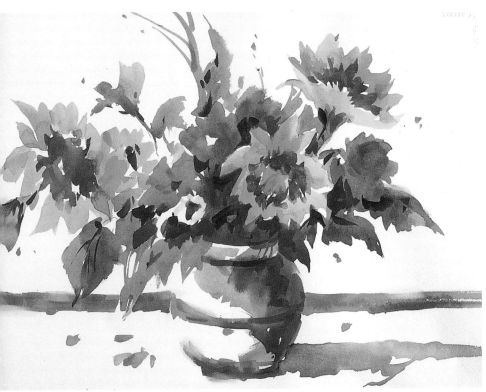

4 Add Details
Add a few violet flowers by mixing red-violet and blue together. Add a few more leaves and some calligraphy. The centers of the sunflowers are painted using various hues of red and a very dark red (red-violet, plus blue, plus yellow) around the outside edges.

Use a 1-inch (25mm) angular flat to introduce a horizontal warm band into the background. Float some cool color into the warm color. Paint the shadow next to the pot with a no. 8 round, applying blue, then red and yellow floated into the wet blue color. This will cause the colors to create a beautiful translucent gray. Add a few little dots of red here and there, some calligraphy with a no. 2 script liner, and the suggestion of some yellow-red petals on the surface.

Sunflowers of Provence • *15" x 22" (38cm x 56cm)* • *Collection of the artist*

Pushing the Color

materials

Pigment • Aureolin Yellow • Quinacridone Gold • Red Rose Deep • Phthalo Blue • Phthalo Green

Brushes • 1-inch (25mm) angular flat • No. 2 script liner • Nos. 8 and 20 rounds • Child's toothbrush

Paper • 140-lb. (300gsm) cold-pressed Arches, 8" x 17" (20cm x 43cm)

Whether it's people or animals, I always try to capture the personality of the subject. I'm looking for that special look or gesture that speaks to me. I observed this rooster until he looked just right then snapped the photograph. He had a cocky attitude and I wanted this to come across in the demonstration. Also, I *pushed the color* making it more than it really was for greater visual impact.

Reference Photograph
I found this handsome guy on a trip to photograph koi fish. He was an unexpected bonus.

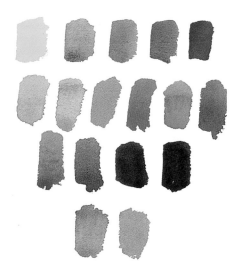

Color Palette
First row: Aureolin Yellow, Quinacridone Gold, Red Rose Deep, Phthalo Green and Phthalo Blue
Second row: Aureolin Yellow is individually mixed with each additional color. Aureolin Yellow plus a little Quinacridone Gold; Aureolin Yellow plus a little Red Rose Deep for a yellow-orange; yellow-orange plus a little more Red Rose Deep creates orange; orange plus a little more Red Rose Deep produces orange-red; Aureolin Yellow plus a little Phthalo Green; this green mixture with a little Phthalo Blue producing a middle value green.
Third row: Quinacridone Gold plus Red Rose Deep; Quinacridone Gold plus Phthalo Green; Quinacridone Gold plus Phthalo Blue; and Quinacridone Gold plus Phthalo Blue with a touch of Red Rose Deep
Fourth row: The gray mixtures are made from blue, red and a touch of yellow.

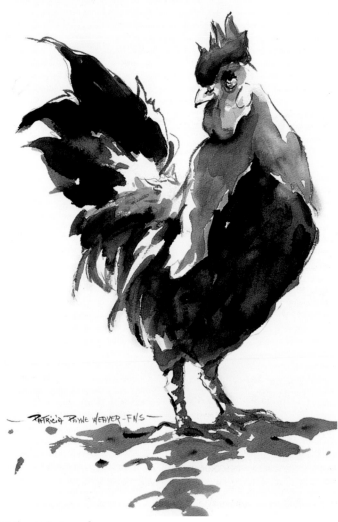

Value Painting
The black-and-white value painting was a big help in establishing the values I wanted. It's always a good idea to familiarize yourself with the subject before you begin the painting process. Consider the value painting as a warm-up.

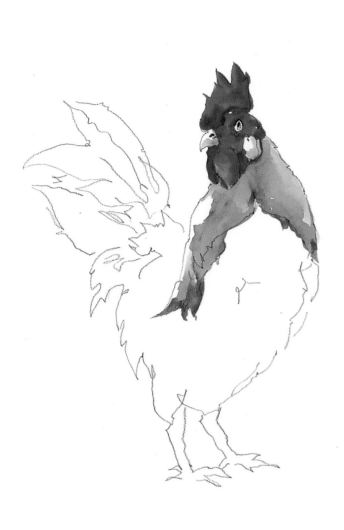

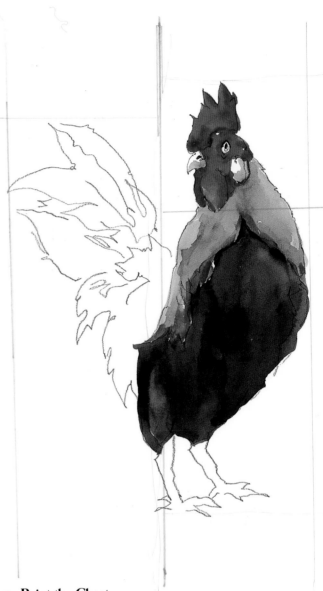

1 Paint the Head

After establishing a good and accurate drawing, start the painting using the same palette in *Sunflowers of Provence* (pages 95–97). Paint the comb and wattle with a no. 8 round using a variety of reds. There is only one red in the palette so either add yellow to the red to warm and lighten the color, or add blue to darken and cool it. Don't forget when adding blue to add a little red and a touch of yellow back into the second mixture to keep it in the red family—too much blue will make violet or blue-violet. Paint the area beneath the head with grayed yellow (Quinacridone Gold) and a touch of red-violet. Float in a touch of blue for some cool relief.

2 Paint the Chest

Paint the chest with a no. 20 round applying blue, then introduce green and a touch of red-violet to darken the blue. Paint everything consecutively, not allowing the paint to dry when changing colors.

Selecting brushes

Remember, the bigger the area, the bigger the brush. The feathers could also be painted with a no. 20 round brush. I switch back and forth, mostly preferring the angular flat brush, which is very versatile.

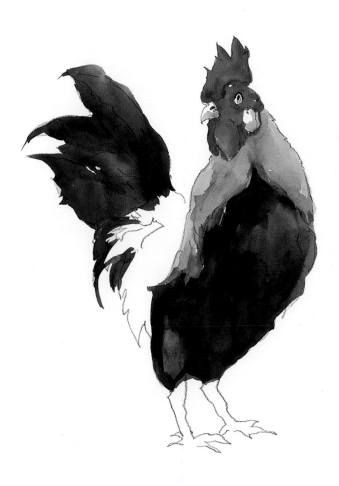

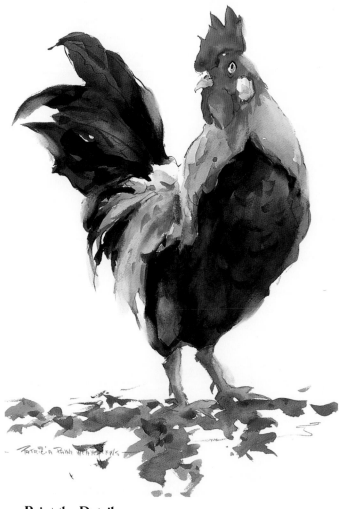

3 Paint the Tail

Paint the tail feathers with a no. 20 round. Use juicy paint and rich dark values of blue, green and a little red-violet introduced directly into the wet paint. Lift a little color with a damp, not a wet, brush.

4 Paint the Details

Apply the final touches with the no. 8 round by finishing the feathers with the grayed yellow and red-violet. Paint the legs with grayed yellow, red-violet and a touch of blue. Paint the shadows with all of the colors that are in the rooster. Keep these shadows an overall warm with accents of cool. Use a no. 8 round for the shadows.

Use a child's toothbrush, dipped in water and blotted on a soft paper towel, to soften edges on some of the tail feathers and the body of the rooster. Hard edges all over can make the subject look like it's cut out and pasted to the paper. Some softened edges prevent that look.

Struttin' My Stuff • *22" x 15" (56cm x 38cm)* • *Collection of the artist*

Tips

* Don't smell your paper. When you sit down to paint, your nose is practically on the paper as you work. Stand up if you can and get away from the board.

* Paint with your entire arm, not just your wrist and your fingers.

* Hold your brush farther back on the handle, not at the metal ferrule. This allows for a light touch.

* Have plenty of water and pigment for a juicy paint consistency.

* More water lightens the color and less water darkens the color. Hands-on experience will teach you how much of each to use.

Using Complementary Colors

materials

Pigment · Aureolin Yellow · Quinacridone Gold · Red Rose Deep · Phthalo Blue · Phthalo Green

Brushes · 1-inch (25mm) angular flat · No. 2 script liner · Nos. 8 and 20 rounds

Paper · 140-lb. (300gsm) cold-pressed Arches, 8" x 17" (20cm x 43cm)

This demonstration is a study of the complementary colors orange and blue, linking shadow shapes, the use of white paper and extreme contrast really pushing the value and color of the sky against the light on the buildings. The ultimate goal here is to exaggerate the sky making it very blue against the bright orange color on the roofs.

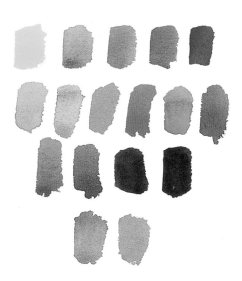

Color Palette

First row: Aureolin Yellow, Quinacridone Gold, Red Rose Deep, Phthalo Green and Phthalo Blue.

Second row: Aureolin Yellow is individually mixed with each additional color. Aureolin Yellow plus a little Quinacridone Gold; Aureolin Yellow plus a little Red Rose Deep for a yellow-orange; yellow-orange plus a little more Red Rose Deep creates orange; orange plus a little more Red Rose Deep produces orange-red; Aureolin Yellow plus a little Phthalo Green; this green mixture with a little Phthalo Blue producing a middle value green.

Third row: Quinacridone Gold plus Red Rose Deep; Quinacridone Gold plus Phthalo Green; Quinacridone Gold plus Phthalo Blue; and Quinacridone Gold plus Phthalo Blue with a touch of Red Rose Deep.

Fourth row: The gray mixtures are made from blue, red and a touch of yellow.

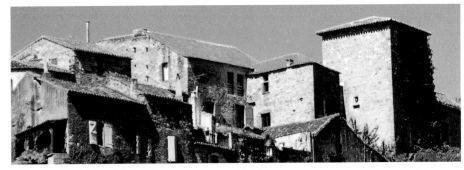

Reference Photograph

This photo was taken on a trip to France in 1999. This village is very old and every little shop had wonderful books in it. I was intrigued by its history and the fact that it was built on a high rocky cliff. The strong geometric shapes make for a wonderful and interesting composition.

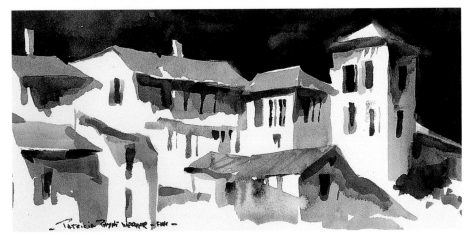

Value Study

You want good strong value contrast in the value painting, again stressing the linkage of the lights and the linkage of the darks. The format was established from the cropped photograph and I made sure that I stayed with this same format for the painting. Discipline yourself to go through the process of cropping and doing thumbnails. When you are happy with the end result, make sure that when you begin the painting, the shape of the paper is the same as the thumbnail so that everything will fit (see pages 52 and 53). I like the long skinny horizontal format for this particular subject.

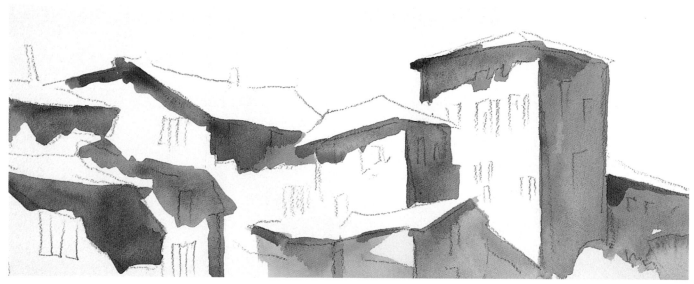

1 Paint the Linking Shadow Shapes

With a 1-inch (25mm) angular flat, paint all the linking shadow shapes by mixing a neutral gray using blue, red and yellow. While the neutral gray is still wet, introduce red, then yellow, then a touch of blue, giving variety to the shadow colors. Use blue sparingly and stay away from Phthalo Green in the shadow shapes.

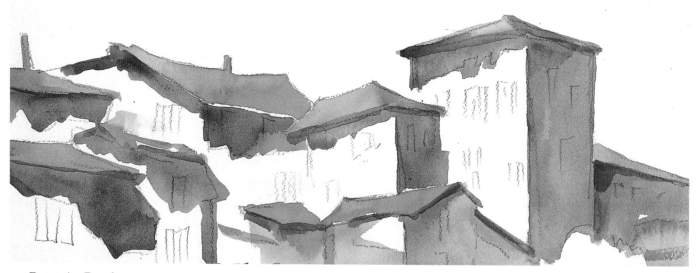

2 Paint the Roofs

Paint the roofs with a no. 8 round using various hues of orange by mixing yellow with red. Add a touch of blue now and then.

Balancing color

When there is an area of warm color, I always introduce a cool color into it. The same is true when the overall color is cool. I will introduce some warm color. It's all about opposites, push-pull or yin-yang.

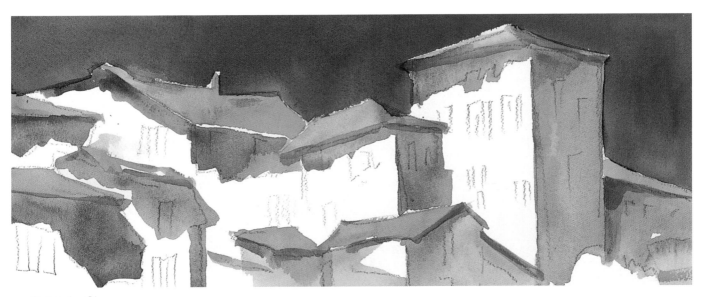

3 Paint the Sky

Paint the sky with a no. 20 round by introducing blue with a touch of red-violet. Make sure the value of the sky is dark enough that it contrasts against the roofs.

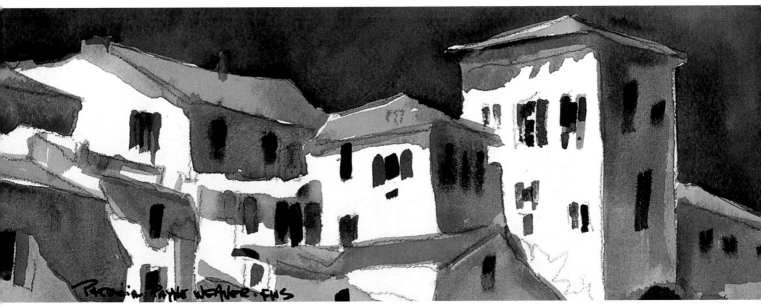

4 Add Final Touches

Repaint the sky to place in some darker values, still using blue and a touch of red-violet. Add the windows using a no. 8 round, making sure to vary the size, shape, color and values. Introduce a little dark green foliage. Note the contrast and the strength of the values of the shadows against the white of the paper. This is an overall warm painting with an accent of cool.

Village of Books • 7" x 17" (18cm x 43cm) • *Collection of the artist*

Painting With a Grayed Palette

materials

Pigment · Cadmium Red Light · Burnt Sienna · Quinacridone Gold · Ultramarine Blue

Brushes · 1-inch (25mm) angular flat · No. 2 script liner · Nos. 8 and 20 rounds · Child's toothbrush

Paper · 140-lb. (300gsm) cold-pressed Arches, 15" x 22" (38cm x 56cm)

I had a surprise encounter with this sleek Siamese cat on the way to my car in a parking lot. It was a brisk morning and the cat was happy to stretch out in the sun. I just happened to have my camera handy and took several photos. The cat was very cooperative in posing and I was happy that we met. He was the "purr-fect" subject for using a limited palette of grays.

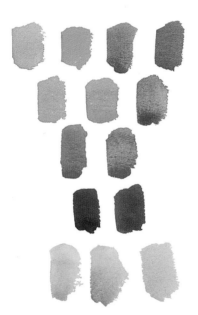

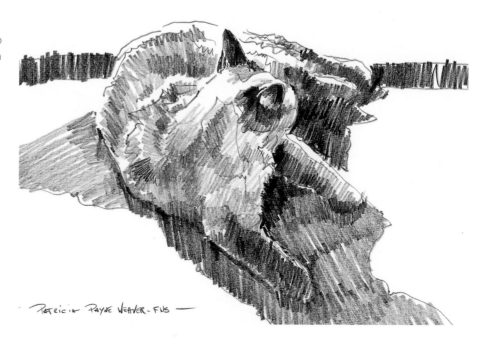

Reference Photograph
The relaxed pose of the cat and the long shadow shapes are interesting, setting up a fun subject to paint.

Color Palette
First row: Quinacridone Gold, Cadmium Red Light, Burnt Sienna and Ultramarine Blue.
Second and third rows: Quinacridone Gold and Burnt Sienna are both grayed colors (tertiary) so they produce grays when mixed with Cadmium Red Light or Ultramarine Blue.
Fourth row: Black is easily made from Ultramarine Blue and Burnt Sienna, keeping blue as the dominant color.
Fifth row: Yellow is in Cadmium Red Light, so it creates a gray color when mixed with Ultramarine Blue. Remember when you mix all three primaries together you produce a gray color (tertiary).

Value Sketch
I added the horizontal band across the top to create interest. I used a 4B and 6B pencil for this thumbnail sketch of the cat.

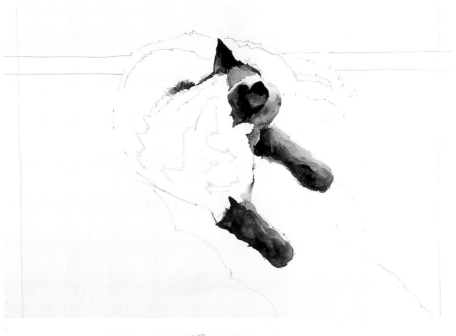

1 Paint the Dark Areas of the Cat

Start with the ear using a no. 8 round to introduce pure blue into the ear and then while wet add a dark concentration of Burnt Sienna. Use very little water so that the value will stay dark. The colors have to be juicy enough not to have a drab, dry appearance. Apply Quinacridone Gold to the head, reserving some white paper. Apply the same darks to the legs, but introduce Burnt Sienna followed by yellow, next to the darkest value. This way the legs are going from dark to middle to light to middle to light value. And they are moving from a cool dark to middle warm to lighter warm. This causes the legs to have a rounded appearance.

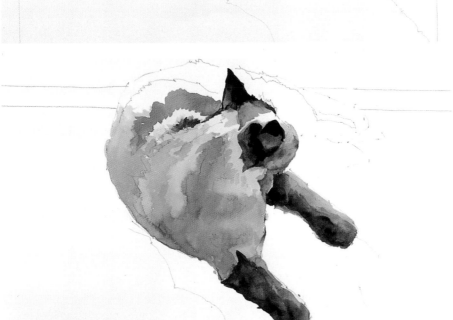

2 Paint the Body of the Cat

Still using the no. 8 round, apply Quinacridone Gold with more water to lighten the value of the cat's neck and back areas. While still wet, add a slightly darker value of the same color, but with less water in the mix this time.

3 Paint the Hind Legs

With a no. 8 round, paint the back legs using the black mixture of blue and dark Burnt Sienna for the darkest darks, followed by dark orange plus yellow, then just yellow. If the colors are lighter, then more water is needed; if the colors are darker, then less water is needed. Reserve a little white paper across the back of the legs and hip.

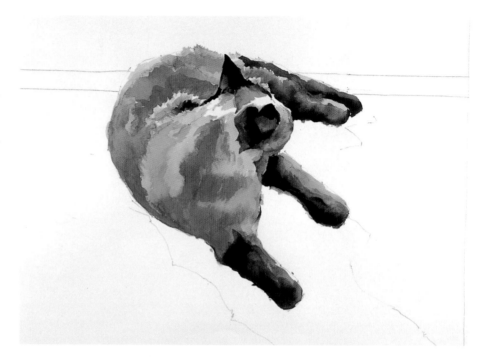

4 Paint the Shadows and Background

Paint the shadows under the cat with a no. 20 round using the same colors that are in the cat. Use blue and dark orange in the dark areas. Use yellow and red with a touch of blue as the shadow comes into the light. Paint the lighter shadow behind the cat with a very light value of yellow and float a little blue into the wet pigment. Paint the horizontal band using a 1-inch (25mm) angular flat with blue plus dark orange. Use a no. 20 round to paint the area above the band with Quinacridone Gold at a number 3 value with a little bit of blue floated into the wet pigment. Lose a few edges using the damp toothbrush. Finally, use a no. 2 script liner to apply a few whiskers with a dark value of very thin paint.

Siamese • 15" x 22" (38cm x 56cm) • *Collection of Margaret Roberts*

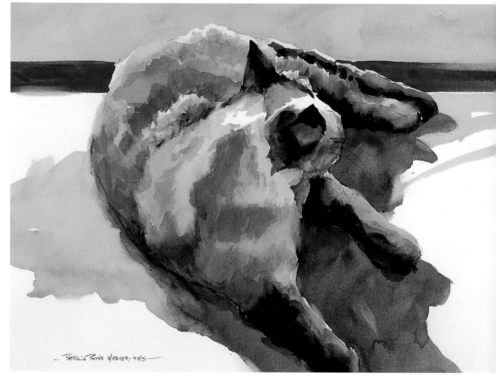

Big Simple Shapes—Simple Warm Palette

materials

3B pencil

Pigment

Quinacridone Gold •
Quinacridone Sienna •
Ultramarine Blue •
White gouache

Brushes • No. 2 script
liner • Nos. 8, 12 and
30 rounds

Paper • 140-lb.
(300gsm) rough Arch-
es, 18" x 20" (46cm x
51cm)

So many of the animals that I paint are chance encounters. This basset hound was on a leash with his owner and I asked for permission to photograph him. The basset was very obliging, sat right down with a sad-sack expression just as if he knew what was going on, and gave me some very funny material to work with. Capturing his casual attitude was a snap. I focused on the large, simple shapes, like his ears and nose, and kept my palette of warm darks very limited.

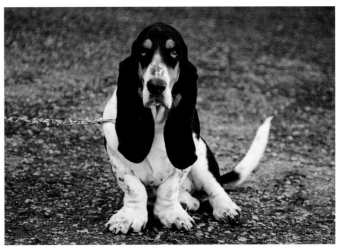

Reference Photograph

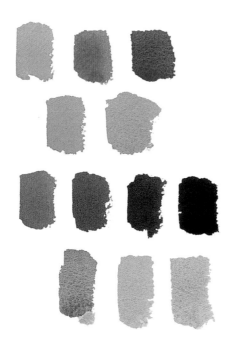

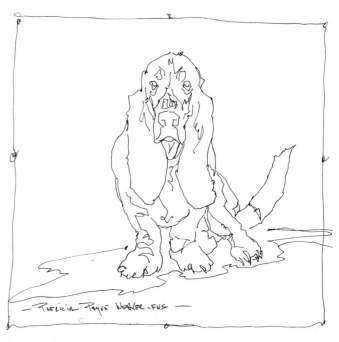

Line Drawing

This simple line drawing in pen and ink helps to create familiarity with the subject and establishes the square format.

Color Palette

Top row: Quinacridone Gold, Quinacridone Sienna and Ultramarine Blue.

Second row: Quinacridone Gold with a little Quinacridone Sienna, and Quinacridone Gold with a little Ultramarine Blue.

Third row: Quinacridone Gold with a little Quinacridone Sienna plus a touch of Ultramarine Blue, a little more Ultramarine Blue is added to the first mixture for each of the next three swatches.

Fourth row: Grays made from the original three colors in the palette. More water is added to lighten the value and there is a distinction between warm and cool.

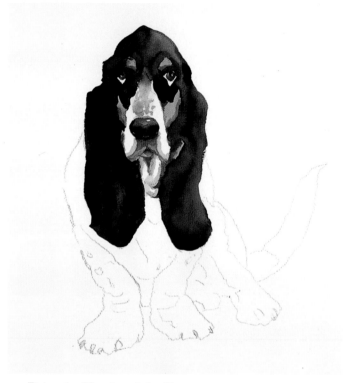

Value Study

The simple line drawing was used to work up a value study with a felt-tip pen. The face and ears are the most important features of this basset hound so they are emphasized in the value study.

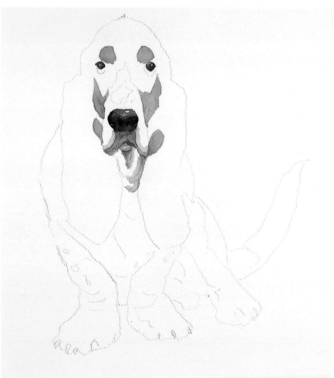

1 Begin With the Face

Draw the subject with a 3B pencil on 140-lb. (300gsm) rough Arches paper. Keep simplicity in your drawing. Using a no. 8 round, start with the face using Quinacridone Gold and Quinacridone Sienna to create various yellow colors. Suggest the eyes with an application of Quinacridone Gold and a little Quinacridone Sienna floated into the Quinacridone Gold. Accent the outside edges of the eyes with a mixture of Ultramarine Blue and Quinacridone Sienna.

Make a gray mixture using Ultramarine Blue plus Quinacridone Sienna for the area under the nose. Apply Ultramarine Blue plus Quinacridone Sienna to the nose area. Reserve a small highlight at the top of the nose.

2 Paint the Head and the Ears

Use a no. 12 round to paint the darks in the head and ears. Apply juicy Ultramarine Blue and immediately float Quinacridone Sienna directly into that wet color to create black, but not a solid black. This method allows you to see the individual colors as well as the warm and cool temperatures.

With a no. 8 round apply a neutral gray made from Ultramarine Blue and Quinacridone Sienna to the area above the nose and into the folds of skin under the jaw.

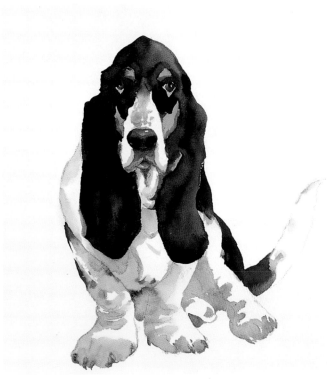

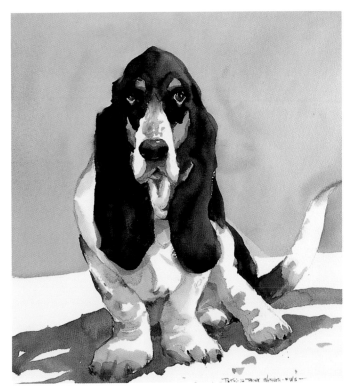

3 Paint the Body

Since the body is white with small accents of dark, it is only necessary to paint the areas that are in shadow. Use variations of grays made from Ultramarine Blue and Quinacridone Sienna for the shadows. Occasionally introduce a little Quinacridone Gold into these grays for an accent of warm into the cools. Be sure there are at least four or five values of gray so that they will snap against the white of the paper. Retain the white of the paper to represent the lights.

Place some dark accents of Ultramarine Blue plus Quinacridone Sienna on the dog's back and on the lower portion of the tail along with touches of gray on the top edge and tip of the tail.

Painting backgrounds

The background should not look like a patchwork quilt. It takes a little practice to learn to float and mop the color. Use plenty of pigment and water for a number 4 or 5 value. Practice painting on white paper. It helps to have a very light touch.

4 Add the Shadows and Background

Paint the shadows under the dog wet-on-dry using a no. 12 round. Start with Quinacridone Gold and while still glistening wet, introduce Quinacridone Sienna. Occasionally introduce a little Ultramarine Blue into the warm shadow shapes. These shadows should be about a number 6 or 7 value.

Paint the background with a no. 30 round floating the color in a loose and juicy manner. Begin placing the color into the background using a mopping motion with the brush, floating the color from the top to the bottom. Introduce Quinacridone Gold. While that is still wet, add Quinacridone Sienna. Keep alternating these colors and from time to time then float in a little Ultramarine Blue.

The final touch is the highlight in *Mr. Personality's* eyes. Purposely make the right eye a little more important than the left eye and use a touch of white gouache for the accent. Both eyes cannot be equally important. This is an overall warm painting with an accent of cool, simply done, but effective. Finish by signing the painting using a no. 2 script liner and thin paint. Place the signature to balance the painting.

Mr. Personality • *20" x 18" (51cm x 46cm)* • *Collection of the artist*

Achieving a Likeness by Saying More with Less

My friend Jennie has a menagerie of animals that she usually rescues and provides with a nice home. This is one of her little bunnies. The painting of *Floppy Ears* (see page 118) is the same bunny, shown there in a different pose. My goal in painting animals is to capture their personalities and to impart to the viewer the essence of the animal without painting every little hair. If I wanted to copy the animal literally, I'd just photograph it and frame the photo.

There's a very big difference between a colored drawing, which is filling in between the lines of a finely detailed drawing, and a painting that is painted in a painterly fashion, with little detail and much emotion. I don't usually use black in paintings, but in this case I decided to try it and I liked the end result.

Reference Photograph

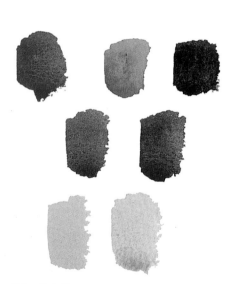

Color Palette
First row: Ultramarine Blue, Quinacridone Sienna and Peach Black
Second row: A dark brown made from Ultramarine Blue plus Quinacridone Sienna. A little more Ultramarine Blue added to that same mixture creates a dark blue gray (like Payne's Gray)
Third row: Both grays are made from Ultramarine Blue and Quinacridone Sienna. One is warmer, one is cooler.

Line Drawing
A simple line drawing using pen and ink helps establish the composition. On the finished painting, I extended the space around the rabbit as the format for the drawing appears crowded. I use white card stock for most all of my drawings. I like the weight of it and it's bright white.

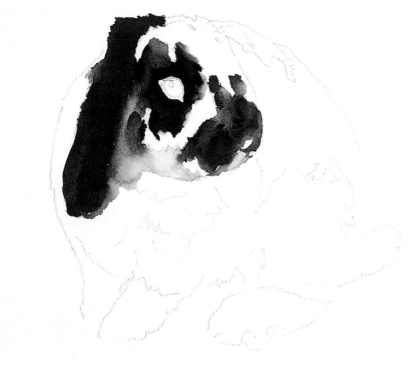

1 Begin With the Head and Ear

On 140-lb. (300gsm) rough Arches water-color paper, use a no 8 round to paint the ears, the areas around the eyes and the area above the rabbit's nose alternating between Ultramarine Blue, Peach Black and Quinacridone Sienna. Introduce a little watered-down gray mixture from the Ultramarine Blue and Quinacridone Sienna into the jaw area.

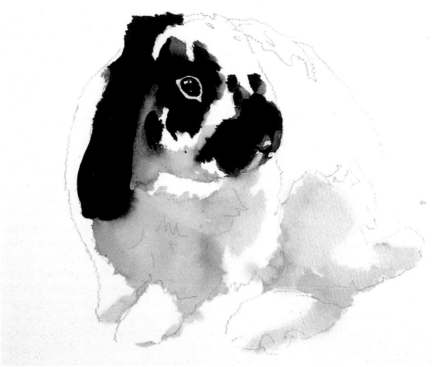

2 Paint the Chest and Lower Body

Using a no. 12 round, paint the grays for all the shadow shapes on the lower body of the rabbit including the legs. Keep the white of the paper for the light or white areas—only paint the shadow shapes. Create slight variations in the grays not only in color but in value as well. With a no. 8 round, paint the rabbit's eye with Peach Black. Save a little piece of white paper for the highlight in the eye and around the outside edges of the eye.

3 Paint the Back

Still using a no. 8 round, paint the second ear, keeping a small rim of white paper on the edge. Don't mix the Peach Black and Ultramarine Blue on the palette, but directly on the paper. Create a warm feeling in the ear, by adding a little Quinacridone Sienna directly into the wet dark mix. Continue the application of the darks onto the back of the rabbit.

Go back into the gray areas of the rabbit's body and accent them with darker gray. Add a little calligraphy of black on the feet, etc. Introduce a little warm gray into the white rimming the rabbit's eye.

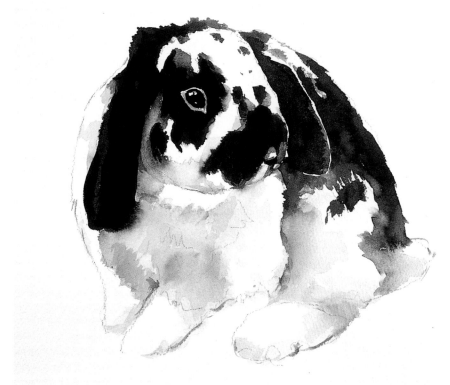

4 Add Details and the Background

Soften the edges on the rabbit's eye using a damp, not wet, no. 8 round. Paint the shadows under the rabbit with variations in the grays and at least a 5 or 6 value. Introduce a little warm (Quinacridone Sienna) into the cool grays. Soften some of the darks in the rabbit's fur.

Paint the background by using a mopping or floating technique with a no. 24 round. This requires quite a bit of water and the value has to stay fairly light so that it reads against the darks on the rabbit. Paint the background grays using all three colors in the first row of the palette. This painting is cool compared to the warmth of the painting of *Mr. Personality* (page 109). Sign the painting with a no. 2 script liner.

Soft and Cuddly • *13" X 11" (33cm x 28cm)* • *Collection of the artist*

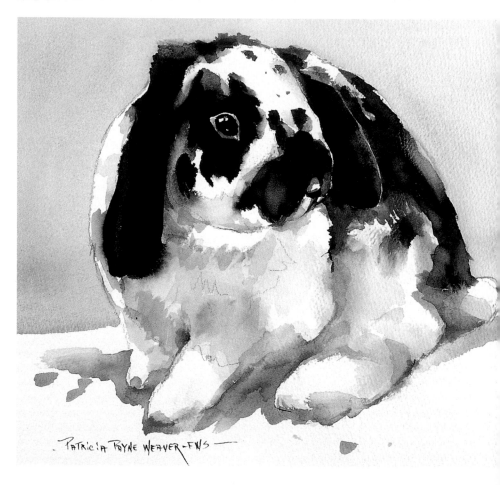

Mastering drawing, value, color and edge control

materials

Pigment · Cadmium Red Light · Burnt Sienna · Quinacridone Gold · Ultramarine Blue

Brushes · No. 2 script liner · Nos. 8, 12 and 30 rounds

Paper · 140-lb. (300gsm) cold-pressed Arches, 15" x 22" (38cm x 56cm)

If you like cats then *Mouser* is an ideal subject to paint, given his attitude and personality. I kept following him around waiting for that right moment to snap the photograph and he turned, gave me the look that said: "Leave me alone already." That was the magic second and I knew when I saw the developed photograph that it was going to be a really fun subject to paint.

This demonstration covers everything. Simple line drawing, a black-and-white value study, a simple palette and four steps of painting. The placement of the head as the focal point is right in the golden section. Edges are a big consideration and my skillful use of the palette enables me to push the colors to the warm side of the palette. I've saved some white paper and provide strong contrast of values. Backgrounds are usually a big problem so when in doubt keep them simple like the background in *Mouser*.

Why work up a palette?

There are many variations of colors, differences in temperature, value and transparency. Without the firsthand experience of knowing what happens when certain colors are combined, you are shooting in the dark when it comes to color application. It doesn't take that much of your time. The more you practice this discipline, the more knowledgeable you become and knowledge is power and gives you freedom.

Reference Photograph

As you can see in the finished painting, I eliminated the background information. Instead, I chose to make the temperature of the background warm to tie into the colors on the cat.

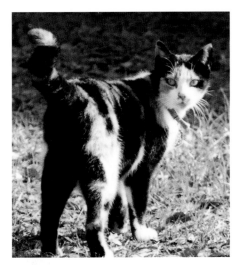

Color Palette

First row:
Quinacridone Gold, Burnt Sienna, Permanent Rose and Ultramarine Blue.

Second, third and fourth rows: All these colors are combinations of the first row palette. See if you can look at the colors and make them for yourself. This is excellent practice. I could continue to lead you by the hand, but this is a good time for you to go it alone.

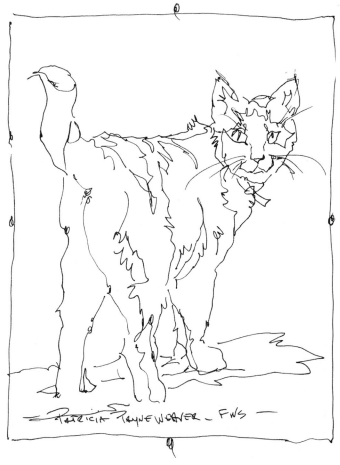

Line Drawing

I spent about five minutes doing a quick little pen-and-ink drawing, using the dot-to-dot simple line technique, to carefully measure with my eye as I move the pen over the paper. This process helps you understand the subject. Remember it's very important to get the drawing right. There's no excuse to leave it incorrect if you know it's wrong.

Value Plan

Invest about twenty minutes in a value painting, then you'll know just how the values should read on the cat. In the color painting, you will be pushing the color and values to make them more than they really are. So far your total time invested in the first two steps should be about twenty-five minutes—time well spent.

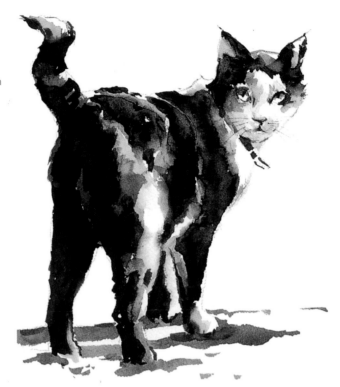

1 Paint the Head and the Middle Values of the Body

Using a no. 8 round, paint the darks on the cat's head beginning with Ultramarine Blue. While the blue is wet, introduce Burnt Sienna. Paint the inside of the ears with grayed Quinacridone Gold and introduce a little red-violet while still wet. The warm colors on the cat's face and back are grayed Quinacridone Gold and dark Burnt Sienna mixed together on the dry paper. Variation of color and values are very important. As you can see, right away you have established middle and dark values against white paper, giving the painting snap. Outline the cat's eyes using the black mixture and paint the marquise-shaped pupils black.

Be aware of your edges even in this first step. Try to soften the edges as you paint. Take note of the areas that have been left white paper on the cat's head as well as the body, legs and feet.

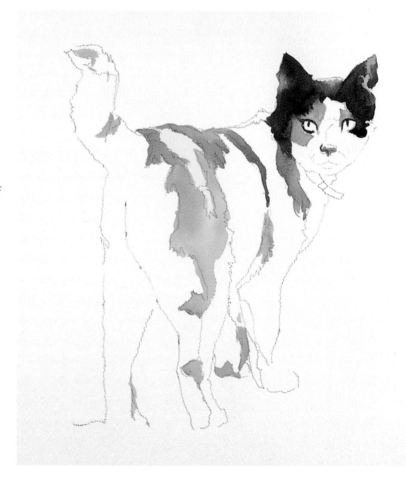

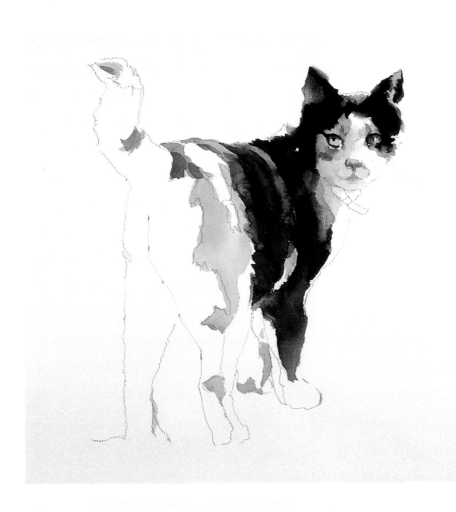

2 Add Dark Values

Continue to apply the dark mixtures of blue and dark orange into the shoulder area with a no. 12 round. Go back into the cat's face applying a little gray mixture of Burnt Sienna and Ultramarine Blue for some shadow shapes. You want this to be a higher value so add more water to the mix.

Paint the mouth area with a little mixture of red-violet, dark orange and black. Add a little accent of dark orange and grayed yellow above both eyes and under the left eye area. Paint the eyes with grayed yellow and a touch of blue. Make one eye a little more important than the other. Never make both eyes the same. This same principle applies to painting people.

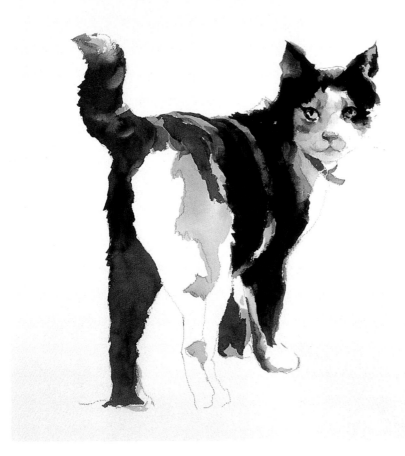

3 Continue to Add Darks

Repeat the same process with the blue and dark orange mixtures into the tail and left back leg of the cat. As needed, introduce more grayed yellow into areas of the fur. While the tail is still wet, lift out some color from the tail area with a semidamp brush, which produces a soft grayish color. Note the change of cool and warm in the leg area. Paint the left front leg with the black mixture, a touch of grayed yellow and dark orange.

Paint the collar with red-violet plus a touch of blue in the shadow area, then add red and red plus a touch of yellow as it comes to the light. Use a little gray mixture of blue and dark orange for the right front foot, then add a touch of grayed yellow.

Tip

The bigger the area, the bigger the brush and the more water used, the lighter the values. Less water yields darker values.

115

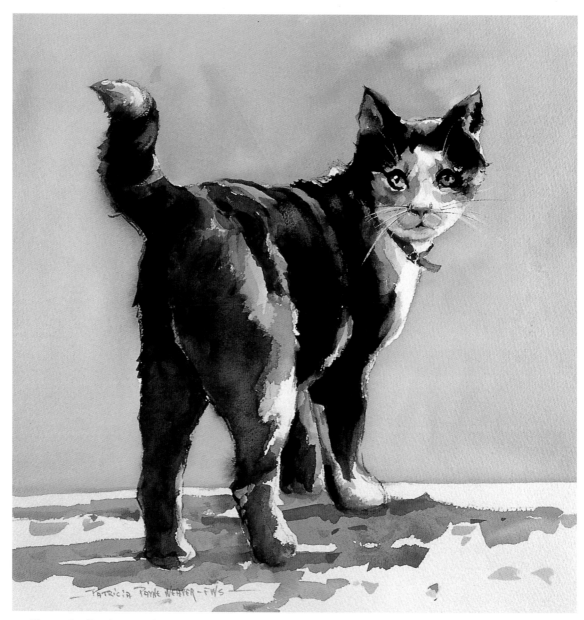

4 Paint the Background

To finish, paint the back right leg with the dark mixture varying the values on the leg so that it will read against the left back leg. It is very important to soften the edges at this stage. Paint the shadows under the cat with variations of grayed yellow, dark orange, red-violet and blue; all wet-into-wet on dry paper and at least a number 6 or 7 value. Add darker accents of the same colors while the paper is still wet. Paint the background with a no. 30 round applying a wash of grayed yellow with dark orange and red-violet introduced onto the dry surface.

Paint the value of the background at about a number 4. This will require lots of juicy color so use more water. Introduce a little blue into the wet background for some cool relief. After the painting is dry, paint the whiskers with a no. 2 script liner using white gouache and a little of the black mixture. The paint should be very thin and the brush in excellent condition for the best results.

Mouser • *22" x 15" (56cm x 38cm)* • *Collection of the artist*

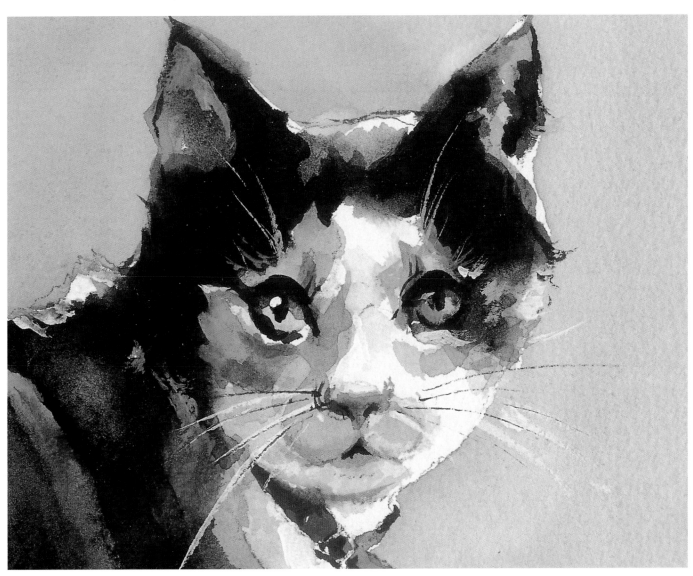

Close-Up of Mouser

Notice the distinct changes of value and color as well as the quality of the
paint and its direct application. The final details are the whiskers and high-
lights in the eyes. The highlight in the left eye is white and the one in the
right eye is gray-blue. *Mouser* is an overall warm painting with an accent of
cool. The middle values are the biggest piece (*Papa*), the dark values are
the middle piece (*Mama*) and the whites are the small pieces (*Baby*).

"In growing, you feel it, your mind, your emotions, your sensitivity all increase over the years." —Claude Croney

Conclusion and gallery of work

Each artist and teacher is a product of the others that have come before. The last painting painted is the end result of everything we've been exposed to, learned or discovered on our own. An artist should never stop growing, always seeking more knowledge and a higher level of skill. This book has only touched the surface of the fountain of knowledge that is available to you, but it is my hope that you have been inspired by the paintings, instruction and words of wisdom. I don't claim to be all knowing or that, in later years, I will still look at painting the same way I do today. One thing is for certain, my love for painting will always be with me. It has been healing for me, opened doors of opportunity that I never thought possible and afforded me many lasting and loving friendships.

Whatever your reason for pursuing your art, be the best at it that you can be. Put forth your best efforts and never become discouraged. The rewards are great and I promise that you will be in a very select body of people who view the world with eyes that truly see.

I thank my wonderful mother for introducing me to art, classical music and ballet at a very young age. The desire and appreciation of the arts has stayed with me throughout my life and I think she would be pleased.

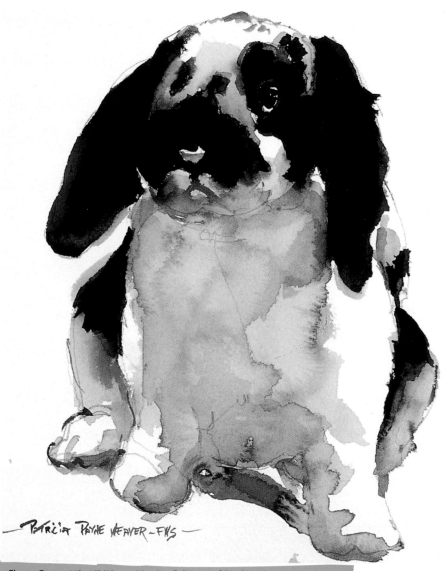

Floppy Ears • *11"x 15" (28cm x 38cm)* • *Collection of Carolyn Kelso*

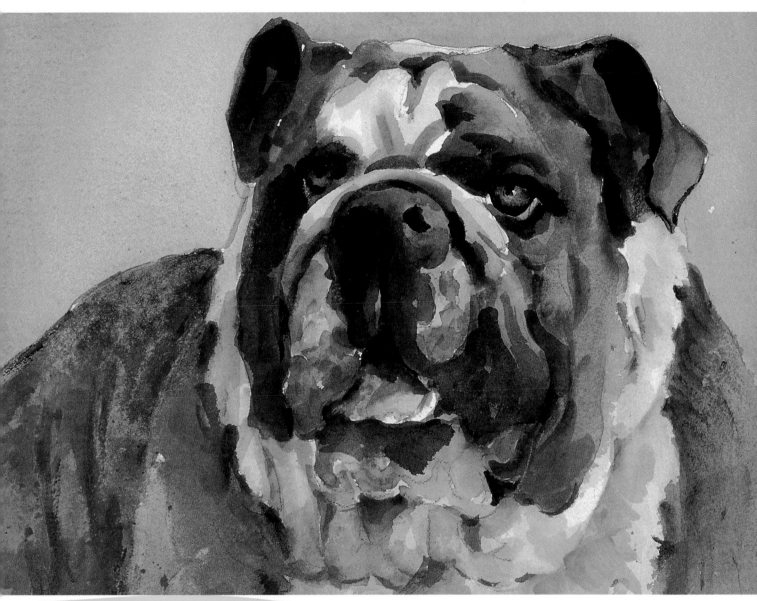

Violet • *12" x 16" (30cm x 41cm)* • *Collection of Sylvia Clark*

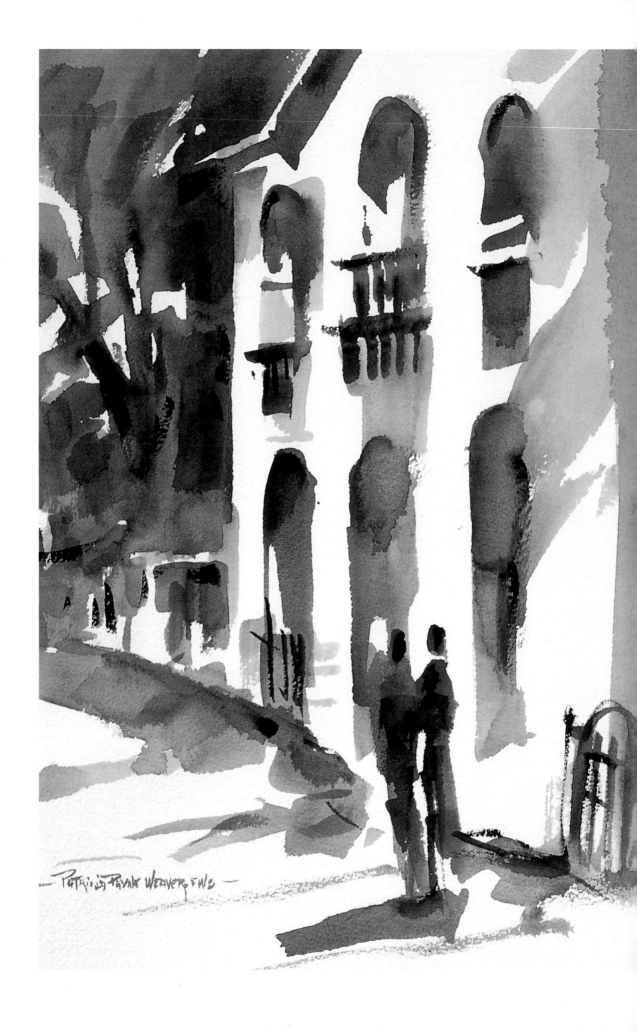

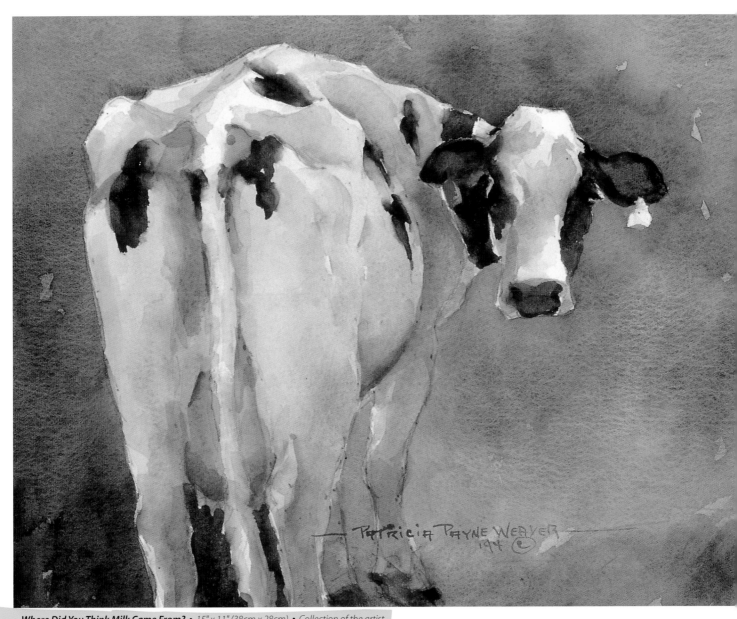

Where Did You Think Milk Came From? • *15" x 11" (38cm x 28cm)* • *Collection of the artist*

Historic Walk • *22" x 15" (56cm x 38cm)* • *Collection of the artist*

Patricia Payne Weaver-FWS

Norman • 15" x 15" (38cm x 38cm) • *Collection of the artist*

Babe • *15" x 22" (38cm x 56cm)* • *Collection of Jane Frist*

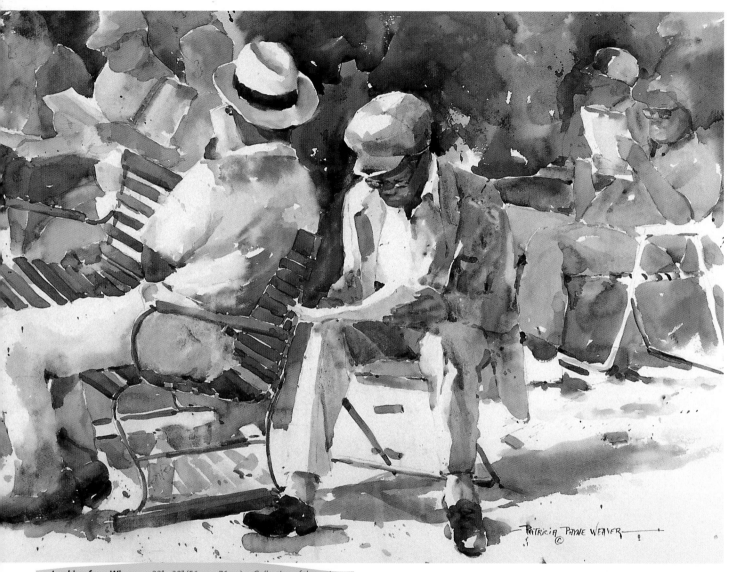

Looking for a Winner • 22" x 30" (56cm x 76cm) • Collection of the artist

> *"I get rid of my weak paintings, so hopefully my standard will be a little higher."* —Claude Croney

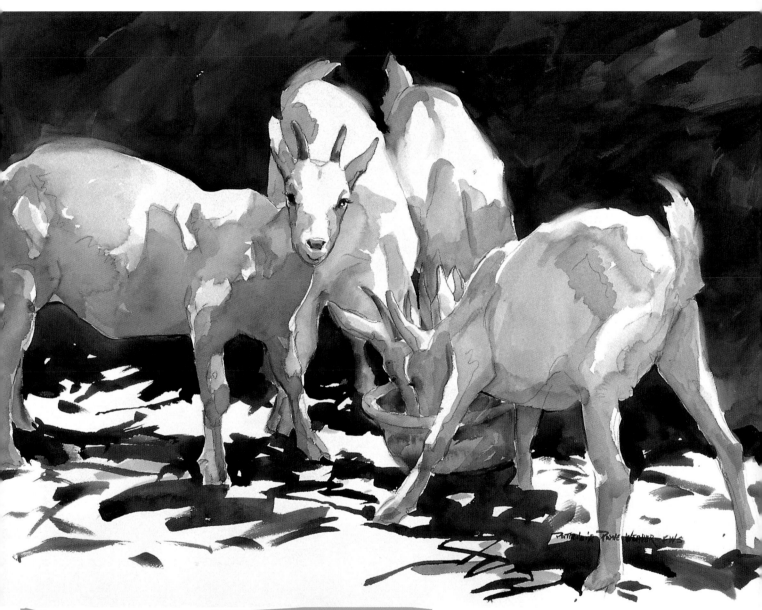

Le Chevres Blanc de Monteferre • *22" x 30" (56cm x 76cm)* • *Collection of Barbara Aras*

Full Sheet
Use for a 22" x 30" (56cm x 76cm) piece of paper

Full Sheet
Use for a 22" x 30" (56cm x 76cm) piece of paper

Half Sheet
Use for an 11" x 15" (28cm x 38cm) piece of paper

Half Sheet
Use for an 11" x 15" (28cm x 38cm) piece of paper

Elongated
Use for an 11" x 30" (28cm x 76cm) piece of paper

Elongated
Use for a 9" x 30" (23cm x 76cm) piece of paper

Square
Use for a 22" x 22" (56cm x 56cm) piece of paper

Elongated
Use for an 11" x 30" (28cm x 76cm) piece of paper

Square
Use for a 22" x 22" (56cm x 56cm) piece of paper

Template

Square
Use for a 22" x 22" (56cm x 56cm) piece of paper

Discover just how much *fun* painting can be!

Mastering basic brushwork is easy with Mark Christopher Weber's step-by-step instructions and big, detailed artwork. See each brushstroke up close, just as it appears on the canvas! You'll learn how to mix and load paint, shape your brush and apply a variety of intriguing strokes in seven easy-to-follow demonstrations.

ISBN 1-58180-168-8, hardcover, 144 pages, #31918-K

Here's all the instruction you need to create beautiful, luminous paintings by layering with watercolor. Linda Stevens Moyer provides straightforward techniques, step-by-step mini-demos and must-have advice on color theory and the basics of painting light and texture-the individual parts that make up the "language of light."

ISBN 1-58180-189-0, hardcover, 128 pages, #31961-K

Nature paintings are most compelling when juxtaposing carefully textured birds and flowers with soft, evocative backgrounds. Painting such realistic, atmospheric watercolors is easy when artist Susan D. Bourdet takes you under her wing .She'll introduce you to the basics of nature painting, then illuminate the finer points from start to finish, providing invaluable advice and mini-demos throughout.

ISBN 1-58180-458-X, paperback, 128 pages, #32710-K

Create your own artist's journal and capture those fleeting moments of inspiration and beauty! Erin O'Toole's friendly, fun-to-read advice makes getting started easy. You'll learn how to observe and record what you see, compose images that come alive with color and movement, and make a travel kit for creating art anywhere, at any time.

ISBN 1-58180-170-X, hardcover, 128 pages, #31921-K

These books and other fine North Light titles are available from your local art & craft retailer, book store, online supplier or by calling 1-800-448-0915 in North America or 0870 2200220 in the United Kingdom.